Foster Caddell's
Keys to
Successful Landscape Painting

A problem/solution approach to improving your landscape paintings

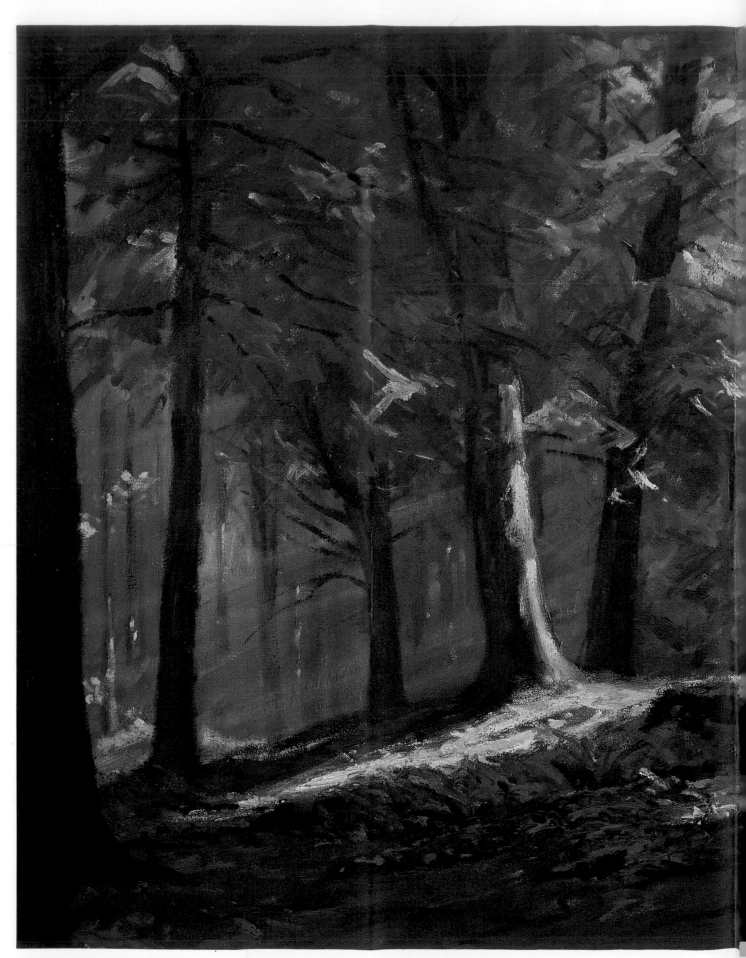

The Light in the Forest, 24″ × 30″

Foster Caddell's
Keys to
Successful Landscape Painting

A problem/solution approach to improving your landscape paintings

*Some live and learn
life is for growing*

*Some live and die,
never knowing.*

— Illon M. Sillman

NORTH LIGHT BOOKS Cincinnati, Ohio

ABOUT THE AUTHOR

Foster Caddell lives and paints in Voluntown, Connecticut, where he has taught at his own art school, called Northlight, since 1955. He previously pursued a career in commercial art and illustration after studying at the Rhode Island School of Design. He has won numerous awards and has exhibited with many prestigious art societies and galleries. He teaches popular workshops all over the country. Caddell is the author of *Keys to Successful Landscape Painting, Keys to Painting Better Portraits* and *Keys to Successful Color*, which together have sold over 90,000 copies.

Foster Caddell's Keys to Successful Landscape Painting.
Copyright © 1993 by Foster Caddell. Printed and bound in Hong Kong. All rights reserved. No part of this book may be reproduced in any form or by any electronic or mechanical means including information storage and retrieval systems without permission in writing from the publisher, except by a reviewer, who may quote brief passages in a review. Published by North Light Books, an imprint of F&W Publications, Inc., 1507 Dana Avenue, Cincinnati, Ohio 45207. 1-800-289-0963. First edition.

97 96 95 94 93 5 4 3 2 1

Library of Congress Cataloging in Publication Data

Caddell, Foster.
 [Keys to successful landscape painting]
 Foster Caddell's keys to successful landscape painting / by Foster Caddell.
 p. cm.
 Originally published: New York : Watson-Guptill Publications, 1976.
 Includes index.
 ISBN 0-89134-474-8
 1. Landscape painting—Technique. I. Title.
ND1342.C27 1993 93-9398
751.45'436—dc20 CIP

Edited by Rachel Wolf
Designed by Brian Roeth

Some of the material in this book was taken from Foster Caddell's books *Keys to Successful Landscape Painting* and *Keys to Successful Color*, which were previously published by Watson-Guptill and are now out of print.

ACKNOWLEDGMENTS

Many people have contributed to the final product that you hold in your hands, and without their help it would not have become a reality. I therefore would like to express my appreciation to the following:

To David Lewis and North Light Books, who felt as I did, that my teaching books should be kept in print and available for the large number of endeavoring painters.

To Greg Albert, whose counsel and cooperation brought this revision to a reality.

To Rachel Wolf for the content editing.

To Brian Roeth for the attractive layout and design.

To Earl Robinson for his patient cooperation in trying to attain the best photography we felt possible.

To Gail Marchant, who helped me with the initial editing and typing.

And to the thousands of people, like you, who purchased my previous books and who, by writing and phoning about how they helped you, gave me the encouragement to write this sequel.

DEDICATION

This book is dedicated to the two most important women in my life—

To June, my late wife, without whose help the previous books and my success as an artist would never have been possible.

To Gail, who is helping me, like the Phoenix, to rise from the ashes and fly again.

Snow Color
I used to think that snow was white
and then, I saw it blue one night
And then, I saw it gold one day
with purple shadows and with grey
And then, one morning it was pink
So now I don't know what to think

—Aileen Fisher

Courtesy of Thom. Nelson Publishers

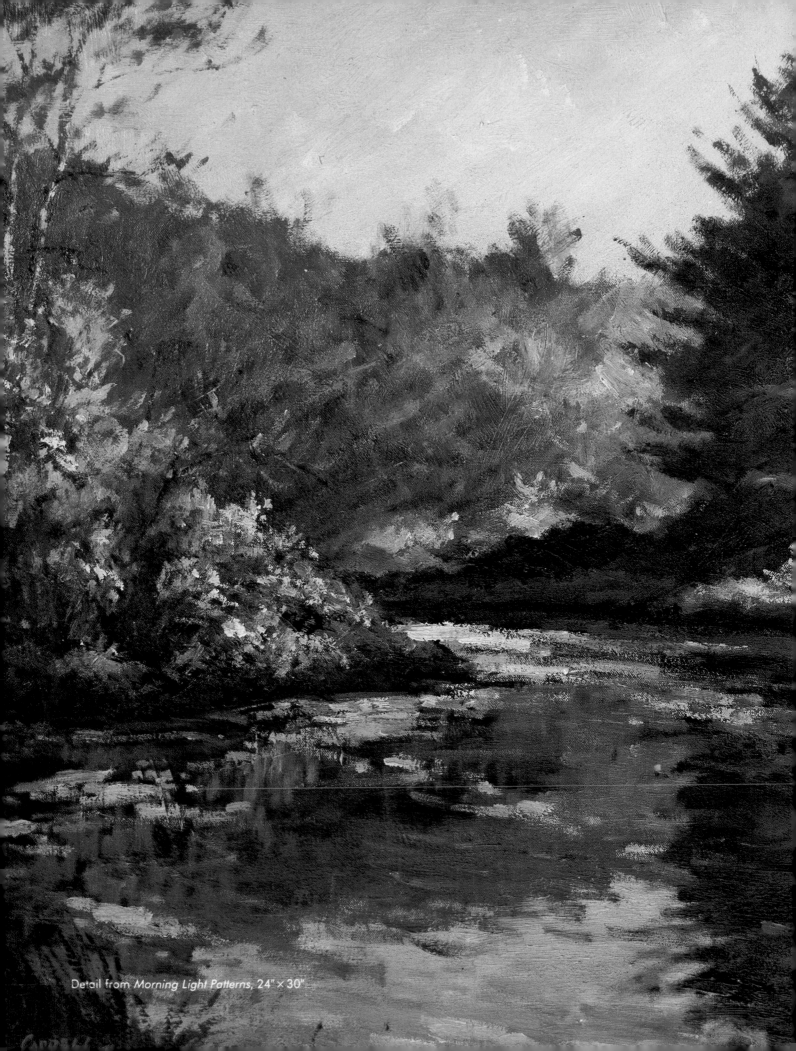

Detail from *Morning Light Patterns*, 24" × 30"

PREFACE

This book is written on the assumption that whatever your level of painting, you would like to be able to paint better.

I have learned a great deal in teaching many students over the years. My main observation is that all students tend to make the same mistakes. I want to point out these mistakes, so you will know when you make them yourself, and teach you how to go about correcting them.

Do not expect to understand or digest the book all at once. Art is a tough master—it gives you back only what you give it. I realize that many students can paint just a few hours a week. If this is your case, be patient with the results. As a teacher, the only thing I am impatient with is student impatience—wanting to produce a good painting before you have accumulated enough knowledge to do so. Keep at it, and each time you paint, you will gain a little knowledge that you can incorporate into your next canvas. The greatest asset a student can have is the *desire* to paint—90 percent of art is dedication and practice; talent only makes it easier. Michelangelo is credited with saying, "If people knew how hard I have had to work to gain my mastery, it would not seem wonderful at all." Just remember: You must balance what you want from your art with what you are willing to give to it.

I want to make one point right at the beginning, because it is so important: In order to be consistently successful in painting, you must see the finished picture in your mind's eye and know just how you are going to achieve it before you start the painting. I realize most students cannot do this—that is why they are students. Making a painting is like planning a trip. You have to know *where* you are going as well as every road and route you must take to get there. It must all become very clear in your mind at the outset and it will, with knowledge and experience. Beginners often paint like a person who gets in a car and tries this road or that, hoping it will be the right one. They do not realize that every stroke on a painting either helps it or hurts it. So many students say, "Oh, I'm just getting something on there," when I notice them painting the wrong color or value. "Something" is not what you want. You should lay color and value in as thoughtfully as you can from the first.

So, to become a good painter, you need the desire, the talent, the practice—and the *training*. Very few painters, no matter how much talent, desire or practice they had, would have made it without help. Life is too short to learn everything by trial and error. I was fortunate to have wonderful teachers who did much to smooth the bumpy road that lay ahead. This is what I sincerely hope to do for you, and, if I do, the time spent writing this book shall not have been in vain.

TABLE OF CONTENTS

Introduction

Painting is really a process of analyzing and synthesizing. The first task is to learn how to see and understand, and the second is to learn the techniques of putting down your perception in paint.

SEEING ACCURATELY

After many years of teaching, I understood something that I had observed early on. Now, after many years and many students, it's the single most important thought I can pass on to you for your development as an artist: *What you know, consciously or subconsciously, prevents you from seeing accurately and analytically.* Seeing analytically is the first step in telling yourself what you should put down on your canvas.

To graphically demonstrate this concept, let me tell you a true story, unbelievable as it may seem, that happened with a student in my class many years ago. This student was an intelligent man—in fact, he was postmaster in our local town—and he desperately wanted to be able to paint as a hobby. As in all my classes, I encourage my students to do some sketching on their own and practice at every opportunity. I suggested that this student go outdoors and make a sketch of his house.

The sketch he brought to class the following week looked rather like my Sketch A (bottom left). The house, broadside without perspective, was not too badly drawn, but the walk going up to the front door looked like a ladder! Never wishing to clobber a student who is really trying, I suggested he go back out and look at the walkway again. I said, "You'll find that it tapers like a railroad track. In fact, you'll find each divisional square of the cement gets smaller as it goes back," and I sketched the correction for him as you see in Sketch B. In all naive sincerity, he looked at me and said, "Foster, it can't! I put that cement walk in myself and I carefully measured each and every square so that I *know* they are all the same."

This is about the simplest demonstration of how what we *know* prevents us from seeing correctly. This happens

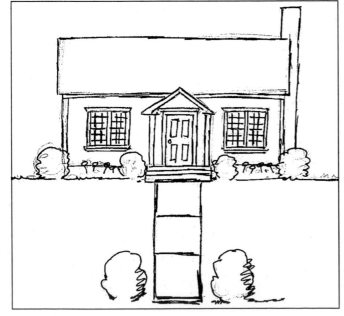

Sketch A

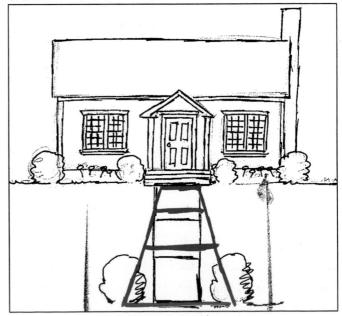

Sketch B

with all students to a greater or lesser degree. We are dominated by preconceived ideas. Skies are blue—water is also blue. Grass is green, tree trunks are brown, white houses are white even on the shadow side, flesh is pretty and pink, etc.

Now that you are aware of this tendency, I hope to train you to see things as they really are—in color, value and drawing. As long as you paint, you must be aware of this common stumbling block and try to avoid it. Keen observation is the answer, and in this book I'll do my best to help you.

THE IMPORTANCE OF STILL-LIFE PAINTING

Another common misconception is held by students who claim they can paint one thing well but not another. This is an erroneous idea—it is just that their lack of ability is more conspicuous in some subjects than others. Your training should be broad in scope, encompassing many different kinds of subjects. I firmly believe that until a student can paint a fairly good still life, he is unable to cope with the other types of painting, such as landscapes and portraits.

Many students look upon still-life painting as boring and uninteresting, but my advice to you is that if you lack the ability to draw well, judge values or mix colors, seek out an artist who thinks as I do, who can train you in still life, for it is the basis of *all* other painting. I was a pretty good landscape painter myself when I realized I had not had enough serious studio painting, so I went back and trained further. (I do practice what I preach!)

In my classes, still life is a *must*. When students can see and render all the subtle nuances on a green glass bottle, for instance, I feel that they'll do a good job the next time they look into a stream and observe the various colors and values of the trees and bushes reflected in the water.

There's no question that studio work is easier than outdoor painting. In a studio, the direction, intensity and color quality of light are consistent. You're able to arrange the actual objects into an ideal composition before beginning the painting; thus, you can paint rather literally. Out-

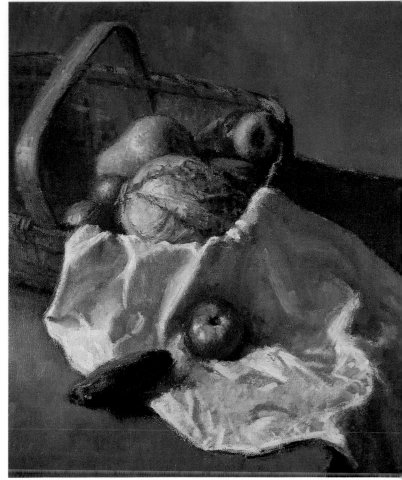

The Market Basket

doors, if you find a subject that's 75 percent perfect, you're lucky. Then it's how you interpret and what you do with the material available that counts. I always tell my students, "If you cannot make it more artistic than a camera would, you might just as well use one!"

Let's look at two of my still lifes. In *The Market Basket*, above, you can see that good art is not governed by great subject matter. If that were so, producing the greatest portrait would only require obtaining the most beautiful model. According to one philosophy, when the subject matter dominates the execution, the painting has failed. Think about that as you look at paintings from now on.

What could be a simpler subject than vegetables and a basket? This painting is handled in a freer manner than the other but is still carried to a reasonable degree of refinement. I am primarily concerned here with modeling solid forms in space and the play of light on them.

3

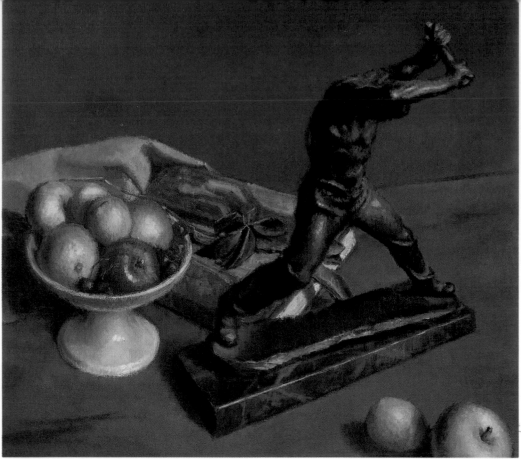

Textures

Textures, my other still-life painting, is refined much further, but I must tell you that there is no secret in painting any surface such as marble, bronze, the ironstone compote or the various surfaces of fruit. The answer to all these problems lies in exquisite observation and the ability to match color and value coupled with good drawing.

That's what good still-life training teaches you! And with these principles going for you, you are ready to tackle the great outdoors.

"KEY" SOLUTIONS TO COMMON PROBLEMS

At this point, I'd like to talk about the structure of this book. On the following pages, I have arranged sets of paintings to illustrate the short instructive guidelines I call *keys*. Each key is explained and illustrated on two facing pages. In most cases, the left side shows a rough oil sketch that incorporates typical painting problems, and the right side shows a finished painting that demonstrates the key solutions to those problems.

I realize that not all of you make all the mistakes I show on the "problem" side of these keys. It's been hard to know just how far to go "wrong" in each exercise, and depending on the ability of each individual reader, the error may at times seem under- or overstated. If you are on your way toward recognizing and solving some of these problems, be thankful—and keep working to overcome the more complicated ones.

In each explanation, I not only discuss the main point, but also mention other mistakes that could be made painting the same subject. Because I have taken my classes out to most of the locations seen in the paintings, the problems I point out are not figments of my imagination but are actually based on observation. I have seen so many students make these same mistakes.

On the problem side, I have not attempted to show you anything other than a color sketch, or study, sufficient to bring out certain points. I have tried to incorporate all the possible mistakes that could be made. In executing these problems, I have even used poor, stubby brushes because I find that most students are not sufficiently aware of the importance of good tools.

Throughout the "solutions," see if you can recognize repeated evidence of the most important principles, such as grouping your lights and darks into interesting patterns and designs, using color and values to achieve atmospheric perspective, and diminishing detail to create distance in a painting. By having the two paintings side by side, you will begin to see and understand just what makes the handling of a subject good or bad, and to recognize the possible pitfalls in a subject so you can avoid them.

Read this book as though you were a guest in my studio being shown some of my recent paintings. First, I'll make a general comment about the painting, for example, explaining why the subject intrigued me initially. I'll also point out some of the problems you should be able to spot right away, how I solved them, and how, in some cases, I captured some of the transitory effects of nature. Then, as I do in my classes, I'll say, "Come closer. Study this little passage here, and notice how it's handled," for a painting should look good at two different viewing distances. First, it should carry well and be commanding at the proper viewing distance of ten or fifteen feet. But then, when the viewer steps up close, he should also take delight in examining the handling and use of color in various small passages. With the use of close-ups in this book,

I'll take you in closer for a more detailed study of some of the paintings.

I'll be repeating many general concepts in these keys, but that's because they're important and because I want to show you how the same principle is used in different ways in different paintings. In my classes, I explain the same principles over and over until students understand them so well that they become part of their own body of knowledge and can put these principles into practice.

Before we get into the keys, which is really the heart of the book, I have included a short section on my painting process. I want you to be able to see how I arrive at a finished painting.

But first, to encourage you in your efforts, I want to show you the first painting I ever did in an outdoor class (below). My teacher at this time was G. Gordon Harris, a prolific and rapid painter, who had us go to a different location each Saturday morning and complete a 12″ × 16″ canvas on the spot. Believe me, there have been thousands of hours of blood, sweat and tears from that point to this!

If you want to be a good painter, there's no way to avoid putting in some long and maybe frustrating hours, but I hope this book can help you avoid some of the common pitfalls.

My first landscape painting.

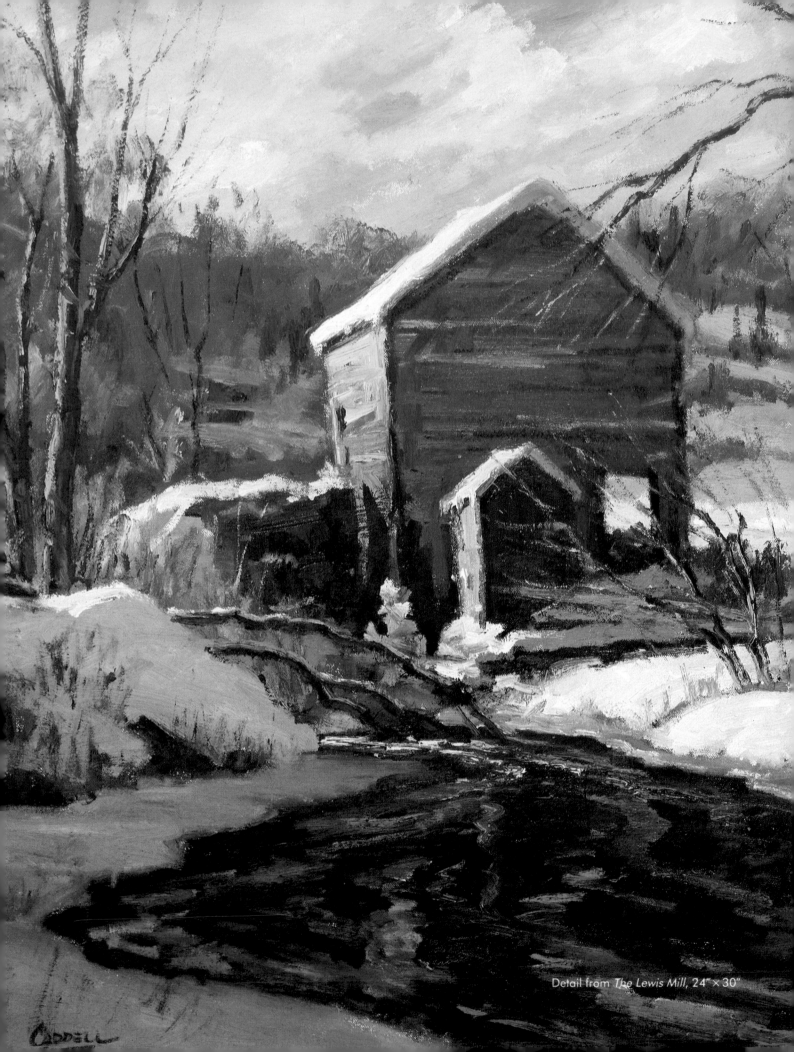

Detail from *The Lewis Mill*, 24" × 30"

CADDELL

The Painting Process

You can go about making a painting in many different ways. There is really no right or wrong way—it's the end result that counts. All I can tell you is what works for me, which is the result of acquiring many years of experience, trying various methods, and incorporating the best of all the teachers who have influenced me.

My method is the same regardless of the subject matter. A landscape, a still life or a portrait would work the same way. The only difference would be the degree of *finish*, or refinement, I feel the particular work needs.

The important thing is to be able to visualize, in your mind's eye, the finished product before you even begin. After careful study of the subject and possibly a few compositional sketches on a pad, you should know exactly the effect you are after and the steps you will take to achieve it. Naturally, this takes years of experience and practice, but I sincerely hope this book will help you along in that direction. Few of us have made it entirely on our own; we have all benefited by those who have tread the path before and are willing to share their knowledge with us.

If you see an artist whose work you admire, listen to his instructions and suggestions and soak them up like a sponge. Don't worry about preserving your individuality at this point. Accumulate as much knowledge as you can—your individuality will naturally evolve as you strive to do your best work.

THE PRELIMINARY SKETCH

The first step in making a landscape painting is deciding what you're going to do with the available subject matter. Designing the canvas is of the utmost importance. Too many students start to draw directly on the canvas. I suggest instead that you get a small sketch pad (9″ × 12″) and solve your problems *before* you touch your canvas. Here are some suggestions on how to do it.

This preliminary stage does not require drawing in great detail. You should just be concerned with the design of the big elements — how much sky will be in the picture, how much foreground, the placement of big masses and so on. Leave yourself room to make changes in your initial sketch by *not* filling the whole page with the sketch. Instead, make a smaller, rough rectangle and sketch the composition within its borders, as you see in Sketch A.

Then indicate the middle of the sketch and make sure you put what's there in the middle of your canvas. Notice that in this case the road ends halfway up the lower part of the composition. Sometimes I see students do a good sketch on their pad but when they transfer it onto the canvas, it looks altogether different.

In Sketch B, you can see how easy it was to enlarge my composition to the left and below because the original rectangle did not fill the entire page.

In Sketch C, while I was designing the composition on location, a chap just happened to be fishing in the stream, so I made a quick study of his body pose on the border of my pad. This was a great reference when I decided in the final painting to include a fisherman in the scene. I even carried it a bit further and suggested a camping area with another chap over the campfire.

Sometimes, I make a couple different sketches from different angles, as you can see in Sketches D and E. I then mull over which is the best angle. In this case, it turned out to be Sketch E. That's how the painting *Beachdale Lane* on page 77 got started.

Some artists feel more comfortable and confident by making a more complete, comprehensive sketch, but this is all I seem to need. Sometimes I make a few indications of shadow areas, but the main thing is that I can visualize the final painting *before* I put brush to canvas.

Sketch A

Sketch B

Sketch C

8

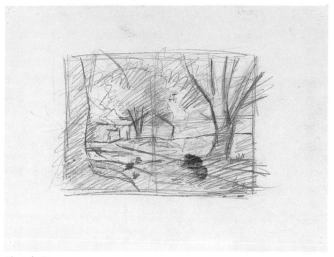

Sketch D

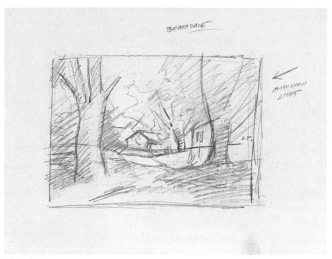

Sketch E

More paintings are spoiled in the first half hour by students wanting to get into the painting too fast. Take time to think it out first, and then when the painting is finished, you won't wish it had been composed better.

To help yourself, go out someday on location with just your sketch pad and practice making compositional sketches of an area. The practice will prove invaluable later on.

MATERIALS AND EQUIPMENT

In most art classes, there's not enough emphasis placed on the mechanics of making a painting. Naturally, art is more than a craft; but, first and foremost, you must be a good craftsman. Before you can express yourself, you need to be in command of the technical means of expression. Everything on your canvas should be deliberate and planned. The artist should run the painting, not vice versa, as is so often the case.

Brushes

I prefer a good-quality, flat, white bristle brush because it has long hair and releases the paint well. I use sizes 1-4, 6 and 8. I use a no. 3 round sable for detail.

At one time, I used a painting knife, but I've since found a brush preferable. Although many students use a painting knife to achieve an artistic effect, many lack control and don't know enough to leave a happy accident alone when it happens. I do, however, use my brush in the manner of a knife quite often, but with control.

Canvas

After years of experimentation, I've settled for a good-quality, medium-weave, linen surface because linen gives the painting greater longevity. But I don't feel that the student needs this—you can spend your money to greater advantage in other ways. Do get a good strong-weave cotton, though. You can determine this by looking at the *back* of the canvas. Many times I use a toned canvas, but for teaching purposes I demonstrate on a plain white canvas, since that's how most of my students work.

Easels

You can't afford to have anything but the best and sturdiest of easels to work on outdoors. Remember, you won't be working under the ideal conditions found in the studio. The ground is uneven, "the wind doth blow," and you'll need a well-constructed easel that serves you well so you can concentrate on painting. I've used the French combination sketch box-easel for years and find it most satisfactory. Always try to remember to position your easel so that the painting surface of the canvas is *not* bathed in direct sunshine. Sunlight gives colors and values a false sense of brilliance, which will fade and flatten when you take the painting indoors. Because of this, artists usually end up facing the sun; hence, a broad-brimmed hat is necessary.

Palette

I find the palettes that come with the French easel too small, so I carry my large, oval, studio one with me

9

outdoors. It's well worth the added luggage. There are many different ways of laying out colors on your palette; no one way is absolutely right. The important point is to have a system and *always* lay your colors out the same way so that your hand knows just where to go for a certain color—like knowing the keyboard of a piano or typewriter. Needless to say, you must always keep the mixing area of your palette clean. I do this when I clean my brushes after a day's painting.

Using the Full Palette

Often, through inexperience in mixing colors, students end the day with certain colors untouched on their palettes. Remembering this, the next time they lay out their palette, they put out fewer colors. This becomes a vicious cycle, for if certain colors are never there, students never learn to use them. Now, being of Scot ancestry, I don't like to waste material. But in learning to use color, you're bound to waste a certain amount, and if a color isn't readily available, you're not going to try to use it. So, to learn to use these colors, you must lay out your full palette of colors before you start painting.

The Starved Palette

While we're discussing pigment on the palette, I'd like to comment on another shortcoming. Many students work with a starved palette—that is, they just don't squeeze out enough paint. Many times I'll remark to students that I *inhale* as much paint as they've squeezed out! You must learn the joy of using enough paint so that the surface of your painting has a patina of pigment as you work one color into or over another. Also, if I don't see lovely color mixtures on students' palettes, I'm quite sure that I'll never see them on their paintings.

Varnish

When I attended classes years ago, I never heard a word about varnishes. But I find them a very necessary part of making a painting. I apply retouch varnish as I work, because as paint dries, it sinks into the canvas and changes color and value. Since my paintings are made over a period of days, when I start to paint, if any part of my canvas is not as glistening as the new paint on my palette, I bring it back to its original wet strength by the application of retouch varnish. If the painting is at all wet, then the varnish must be sprayed on; but if it's dry, it can be brushed on. Be sure that only a *retouch* varnish is used at this stage, since varnish used between the layers of paint must not be too heavy.

When the painting is finished, and after it's completely dry, I apply damar varnish to protect the surface. But I may have to wait six to twelve months after the painting is completed before this can be done. The waiting time depends on the thickness of the paint. The heavier the impasto, the longer it takes to dry thoroughly.

Medium

My advice here is to use as little as possible. Most of the time I use none at all, but I break this rule occasionally if I run into a tube that's too thick or when it's very cold outdoors in winter. Otherwise, I like the thick, creamy, buttery feeling of paint used directly from the tube.

When a medium is necessary, I use a copal painting medium because it is a harder resin than the varnish that is usually used to cover the final painting. When I need a painting to set up and dry fast, such as when painting day after day on the same canvas, I use a medium with a dryer in it.

Paint

I never cease to be amazed at how little students know about the colors of paint they use. Every color in your paintbox should be there for a reason. Some students try to get by with too few colors, and I've found some who have been indoctrinated that earth colors or alizarin crimson are not necessary. On the other hand, the paint manufacturers will produce any color that people will purchase. For instance, I've yet to find a justification for colors like cadmium yellow medium or cadmium red medium, except to fill painting kits that well-intentioned relatives purchase at Christmas time. Over the years, I've tried them all, and here's the list I've settled on for myself and for my students. (I use the same palette of colors regardless of what I am painting because each color does something that none of the others will do. Yet there aren't that many—I still have to do a great deal of mixing on the canvas.)

Basically, my selection represents the warmest and coolest of each color, but I must remind you, unfortunately, that there has yet to be a consistency of color specifications between the various paint manufacturers. At first, you may find it hard to understand the terminology of *warm* and *cool* in paint, because not only are the primary colors referred to as either warm or cool, but also within each individual color there's a warm and cool category. To explain further, yellow is basically thought of as a warm color, but there's a warm yellow—cadmium yellow deep—that leans toward the orange end of the color wheel, and a cool yellow—cadmium yellow pale—that tends to the green side. To use another example, blue is basically thought of as a cool color, but there's a warm blue—cerulean blue—that has more yellow in it, and a cool blue—French ultramarine blue—that contains more purple. Your understanding of all this will come in time. Let's now discuss the colors I do use in more detail.

COLORS

Cadmium red light. This is the warmest of the reds, even warmer than vermilion. Try mixing it with cerulean blue and see what fine grays result because both colors contain yellow, the third primary. And all three primaries mixed together neutralize each other. Keep in mind that most reds, including this one, go colder with the addition of white.

Cadmium red deep. I use this when I need a darker, colder red but don't want it to be as cold as alizarin crimson. This is not a clean color, so when I wish to cool and darken cadmium red light, yet keep it brilliant and clean, I don't use this. Instead I use a still cooler red, alizarin crimson.

Alizarin crimson. This is the coldest of the reds; it borders on purple. It makes a rich purple when mixed with French ultramarine blue, which also borders on purple. Experiment with it in other mixtures—see what happens when you mix it with greens, and try it as part of the three-color balance with blues and yellow earths (e.g., Naples yellow or yellow ochre) in skies, particularly in cloud shadows.

Cadmium yellow pale. This is the coldest of the yellow—even more so than cadmium yellow light. It's as cold as zinc yellow and is more permanent, I'm told. This is used in mixing greens where there's absolutely no breath of red wanted.

Cadmium yellow deep. This is the warmest of the yellows, and having it makes it unnecessary to have orange on my palette. This color is used to make cadmium red light even hotter and is used in mixing greens to get a hint of warm red with the yellow.

Permanent green light. Although some purists prefer to mix all their greens, I find this an exceedingly helpful color. This green has a lot of yellow in it and is indispensable for summer landscapes, although I seldom use it by itself.

Viridian. This is my dark, cool green—try mixing it with white and see how close it comes to cerulean blue. However, it's still not dark enough for some summer greens, and it has to be mixed with alizarin crimson, burnt umber or French ultramarine blue to become darker.

Cerulean blue. This is the warmest of my blues and is great when I don't want a blue that contains red. It's also good for intermixing to make neutrals. Many artists consider this a cool blue because it contains green, but I see it as warmer blue because it has more yellow in it than ultramarine blue, which leans toward the cooler violet shades.

French ultramarine blue. This is a deep, rich, reddish blue. It's a versatile color that's used in many deep mixtures, yet used with sufficient white, it can play a vital part in painting skies and clouds. Mixed with alizarin crimson, it will make a tremendously rich dark—better than black. (If this dark goes too purple, add some raw sienna to neutralize it.)

Payne's gray. This mixture is roughly half black and half French ultramarine blue. I seldom use it as a gray, preferring to mix my own. It has the qualities found in French ultramarine blue, though not as clean. I use it most in formal portraits, when painting the usual dark suit.

Black. Some painters use black with great success, although I prefer not to. I feel it's absolutely taboo for

students, for they'll tend to use it every time they wish to darken a color. Therefore, I *don't* use black.

Earth colors. These I divide roughly into yellow earths and red earths. It may help to remember that reddish earths are referred to as *burnt*.

Naples yellow, yellow ochre and raw sienna are basically different values of the same color. I use them strategically when I wish to add a yellow earth and at the same time either lighten or darken the mixture.

Burnt sienna is a lovely, warm red. When you first experiment with mixing colors, I suggest that you try combining this and French ultramarine blue to make grays, for burnt sienna is basically a combination of red and yellow. Depending upon which of the two colors dominates the mixture, the result is either a warm gray or a cool gray. Then, by adding varying amounts of white to it, you can control the value. This combination has a vast range of uses, from dark tree trunks to the delicate grays of cloud shadows.

Flesh. At first, it sounds strange for a landscape painter to include flesh on his palette. In fact, it's even frowned upon in many circles to have it included in a portrait painter's palette. But, if you just disregard its misleading name and think of it as white with a small amount of red in it, it becomes a very useful color—rather in the same category as Naples yellow, which is white with yellow in it. When you have to mix white with green, for instance, and it needs neutralizing, flesh is very handy. It's also useful in painting skies.

White. Instead of just plain white, I use one of the better mixtures, such as Superba or Permalba white. These contain mixtures of two or more basic whites—zinc, lead and titanium—and this combination, the chemists tell us, gives us the desirable qualities of each.

MIXING COLOR

I don't know whether you've ever thought of it, but there are actually only three colors needed to make a painting—red, yellow and blue. All the rest make painting easier, but they aren't actually necessary. These three colors are called the *primary colors* because you can't get them by mixing any other colors, yet they can mix to form every other color. When you set up your palette, you need enough colors to be practical and helpful, but not so many that you don't need to intermix them. Mixing colors makes for fascinating variations and harmonies.

How to Mix Colors

Students always ask how I mix a particular color, and I usually reply that this isn't like a paint store where you can mix a color by formula, with a quart of this and so many ounces of that. As artists, you must be able to determine the mixture by careful analysis. Mixing is one of the hardest parts of learning to paint because it's difficult to teach in specific terms—it has to be felt and sensed. Most of the time, I mix my colors on the palette automatically, like someone composing music at the piano, where the tune is in his mind and his hands run across the keys to produce the sounds he wants. You may find this hard to understand now, but someday I hope you'll be doing this, too. Then you can concentrate on *what* you are saying, because the *doing* will be almost automatic.

To explain this point in my classes, I often use the analogy of a musician playing a violin. If a piano note is struck, his ear would tell him where to place his finger on the neck of the violin in order to create the same note. As an artist, you must do the same thing with your eyes. Through observation, analysis and practice, you'll learn to see the composition of the color, and then you can select and mix the right colors on your palette.

In general, to mix colors, you must work mostly in one of two directions. If you try to get the most brilliant, pure, vibrant color, you should keep the complements out of the mixture. If you're after a gray, muted effect, the opposite color should be purposely introduced.

One good rule to remember is, if the color in a passage is hard to define—that is, if it's neither a definite primary nor secondary color, but one that's hard to categorize—you'll usually find that it's made up of all three primary colors.

Analyzing the Color Correctly

I'm always saying that painting is a process of analyzing and synthesizing—you *must* be able to predetermine

what you want as the first step to achieving it. I can't stress this too much. Many times, when students claim they can't get a certain color, I look at their paintings and find that very color somewhere else on their canvases. Their greatest problem is not mixing color, but deciding exactly what color is needed because they haven't analyzed correctly the colors they see in the subject.

If you have this problem, too, I suggest taking a negative approach. That is, you may not know what color you want and how to get it, but it's not too difficult to know what you *don't* want. In other words, as soon as you have a few brushstrokes in a certain area, you have to analyze right then and there if it's really the color you want in that area, just as a violinist does when tuning his violin. If he plucks a string and it doesn't sound the same as the note struck on the piano, his ear tells him immediately that it's wrong and whether it should be adjusted up or down the scale. You must learn to get the same information with your eyes.

I josh my students by telling them that all they have to do is mix the correct color and value and put it in the right place. I make it sound easy, but it usually takes many years to become proficient at it. Even professional painters don't mix the correct color and value every time, but as soon as the mixture goes next to the other colors, they know if it's right or wrong. If it's right, they continue to use it, but if it needs adjusting, they immediately do just that. I stress this because for years I've seen students continue to paint a whole passage in what is obviously the wrong color and value. When I ask them why they do it, they say they just wanted to get something down. "Something" is not what you want; it must be as close to the desired finished effect as possible or you're merely getting arm exercise.

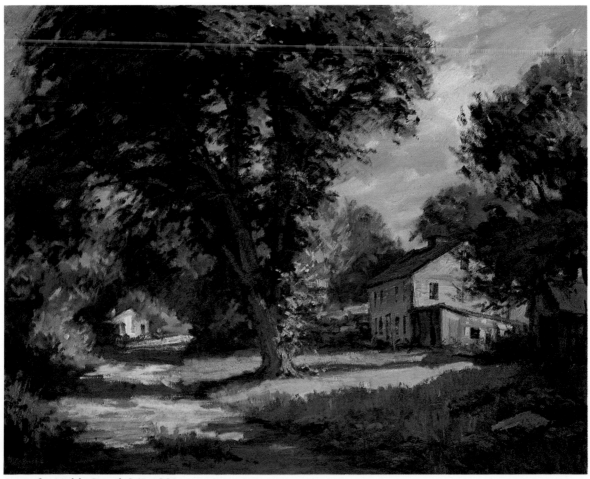

Last of a Noble Breed, 24″ × 30″

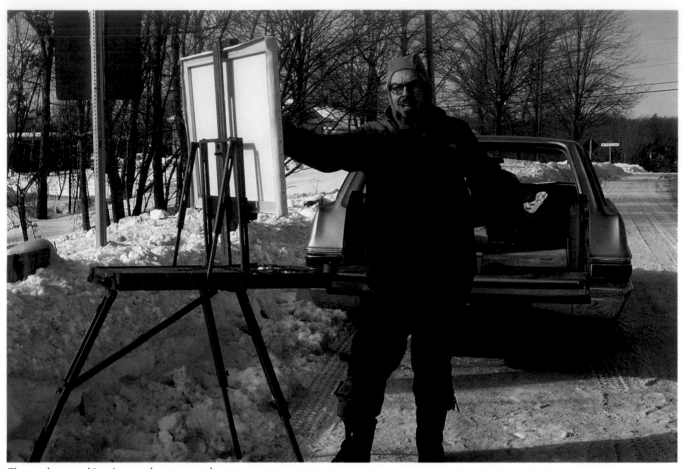

The author working in ten-degree weather.

WORKING OUTDOORS

Just about all the paintings that you see in this book were done on location directly from nature. Other artists paint from slides and photos, but I feel that I do a better job when I'm in firsthand communication with the real thing. It isn't that I can't paint from photos—for years I had to when I was doing illustrations. When I work right on location, I see and incorporate lighting effects and nuances of color that I know would be missed otherwise. Also, I don't end up with ordinary clichéd solutions to problems. I'll be the first to acknowledge, though, it isn't always the easiest or most convenient approach!

The photo above was taken when I was working on the painting *Sunday Morning*, shown on page 103, and the temperature was about ten degrees. Looking back in my day book, I note the entry, "Alarm off at 5:45 A.M., very cold eight degrees. After breakfast, out at 7 A.M. to work on snow painting—worked till 9—hands cold! When I got back to studio, fifteen degrees."

As I've jokingly said many times, "You have to suffer for your art." It isn't always this cold; at the other end of the spectrum, it often can be too hot. One of my familiar quotes to a young student is, "When I can take you out to one of the local ponds or lakes—you're standing there with the perspiration dripping off your ears and the end of your nose as you're trying to paint the reflections in the water, and you're not in there swimming—then there's *hope*!"

OUTDOOR SETUP

The drawing above shows my setup for working outdoors. The French sketch box has served me faithfully for more years than I like to consider. I always work with a cloth or paper towel in my left hand, constantly wiping and cleaning my brush between mixtures. I never swish it in a pot of thinners, for this dilutes my paint too much. On the ground, I keep a roll of paper towels (which I like better than rags), and most important, a paper bag to throw my trash and dirty paper towels into. (*Always* leave the areas you work in with no evidence of human contamination.) Also on the ground, I keep a plastic tray containing my retouch varnish, bug spray and paint thinner for cleaning my palette and brushes when I'm through for the day.

The only item not shown is a big doorman's umbrella that was fabricated into a painting umbrella by a friend of mine. It clamps onto the top of the easel and can be adjusted to any angle to shield both the canvas and the painter from the sun.

Step 1: Designing the Canvas

I cannot overemphasize the importance of this first step. Do not be fooled by the seemingly simple and sketchy appearance. The decisions you make on composition and design at this point will govern how successful your canvas is when completed. Your drawing at this stage should be the skeletal framework of your painting. This is where you find mistakes before you are too deeply involved and correct them before it becomes such major surgery that you are reluctant to attempt it.

In my classes, I stress over and over the importance of being able to draw well. However, a word of caution: The fact that you can draw well does not mean you should draw this stage of the work in great detail. If you do, you may be afraid to get in and paint for fear of losing your careful drawing. A painting is not a map that you draw out and then color in.

My first lines on my canvas are drawn with charcoal because they can be easily wiped off and changed. Even at this stage, I am planning my composition and looking for patterns of lights and darks. If the composition is more complicated than this one, I often dust down the charcoal and reconstruct the drawing with a light earth color such as yellow ochre. This gives me a chance to reconsider my initial decisions. At this stage, I make any adjustments I feel necessary.

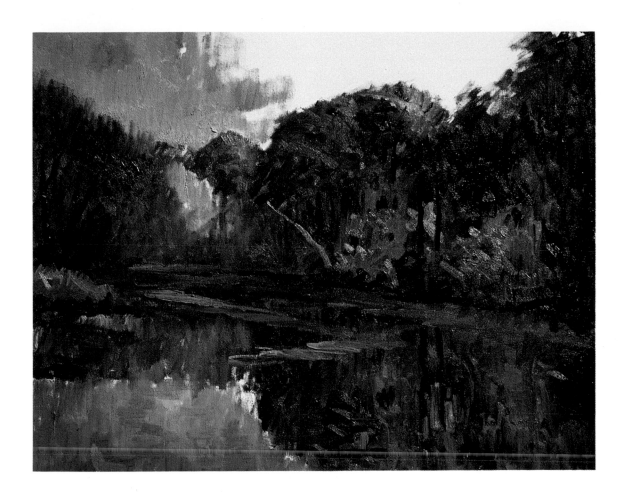

Step 2: Laying in Tonal Values

Now we are ready to start putting paint on the canvas. The main objective now is to cover the white canvas with the big patterns of value and color. A very common mistake is to paint the lights too soon. They are often the interesting passages of the painting, but it is almost impossible to paint lights correctly on a white canvas because there are no other values to relate and compare them to. Technically, we cannot paint light lighter than the priming that is on the canvas, but we can make passages look lighter by their relationship to the middle values and darks they are adjacent to.

The first consideration in starting a painting is to establish the complete range of values—to know where the lightest lights and darkest darks are, because all the other values are gradations in between. Since the bare canvas serves as our light end of the value scale, we should first establish the darkest darks. Then we can begin the process of comparative analysis.

The approach I am using in this painting is to restrict the amount of light in the composition. Light is like everything else in life—the less we have of it the more important it becomes.

The vibrant orange tree you see on the left side in the finished painting (page 19) will not be introduced for some time, because first I underpaint the colors and values that it will best register against.

Think of water as a mirror—but an imperfect mirror with the value range reduced in the reflections. One of the major problems in this painting is to get the darks dark enough to bring out the lights that will be put on later, but still keep them luminous. Almost all the passages you see at this stage will be repainted, adjusted and refined as I go along.

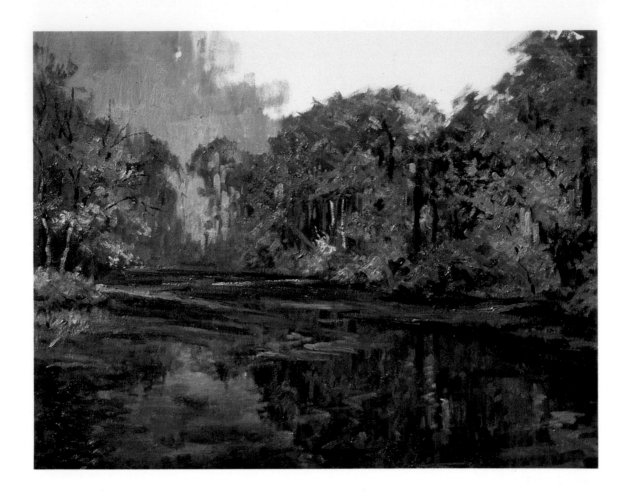

Step 3: Pulling It Together

Every brushstroke you place on the canvas either helps it or hurts it; so my advice to students is to do twice as much *thinking* as *painting*.

Some autumn paintings are very brilliant in color, but this one is rather subdued and quiet. In painting the warm, vibrant colors of autumn foliage, give a great deal of thought to the opposite wavelength of cools they play against — the blues, greens and purples. Also consider the importance of values. Here the dark accents of the tree trunks and the mud along the shoreline make the adjacent values in the shadow foliage appear luminous.

My paintings always convey a sense of where the source of light (in this case, the sun) is. Painting the sky lighter on the side of the sun will enchance this idea, as well as give me a darker sky on the left side, against which

the bright foliage of the orange tree will be displayed.

As skies get darker the higher they go, so also water, the sky's reflector, gets darker the closer it gets to you. Water is usually a value step darker than the sky it is reflecting. Notice how I designed the scum and weeds in the water to make a lovely compositional *S* sweep carrying the viewer into the painting.

In this step, I have further developed the patterns and colors of the foliage in the shadow areas. I have also introduced the tree being hit by light on the left.

There are two basic value patterns in any painting — one formed by the areas hit by light and another formed by those areas cast in shadows. As you develop each of these, you must be careful that you do not lose or destroy the big, simple value pattern as you overpaint.

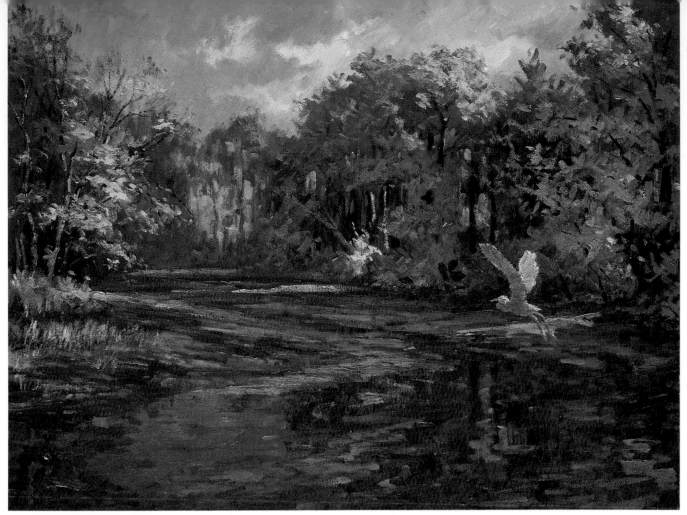

The Silent Visitor, 24" × 30"

Step 4: The Finishing Touches

I want to bring to your attention the variety of brushstrokes I have used in applying the paint. The sky is handled much softer than the trees that play against it. The patterns of floating weeds in the water are painted softly in the direction of the flow of the stream when compared to the definite brushstrokes in the foliage. Although I consider myself an impressionist, I differ from many artists of the French school who handled all passages with the same staccato of rough brushstrokes. I feel there should be variations in handling—even where the color and value are correct.

I also want to stress the importance of painting directly from nature rather than from photographs. While out on location, I am sensitive to any interesting and unusual lighting effects, however transient, that I can incorporate into my interpretation. Such an effect is the beautiful light filtering through the trees and illuminating the bush in the middle of the painting. Also while I was out

there, a lovely heron glided softly into the scene. He stayed but a moment then took off again. I remembered this incident and included the bird in the final painting, not only adding interest to the subject but also supplying a title. I resisted having direct sunlight hitting the heron, keeping the center of interest on the lighted bush. Rather the bird is illuminated from the cool sky above. Notice that the wing facing the sky is lighter than the one facing the water. I made a sketch of the bird and held it in various spots before I finally decided on its placement.

There is an old saying that it takes two people to make a painting—one to paint it and another to hit the painter on the head when it's time to stop. How far one goes with refinement and detail is a matter of opinion. Some painters go to extreme detail; others leave their work very loose and free. Neither way is right nor wrong nor good nor bad. When you reach the point where you cannot see how and where to add a helpful stroke that will improve it—stop!

Detail from *Late Summer*, 24" × 30"

Drawing and Composition

A simple definition of *painting* is placing the right color and value in the right place. That's another way of saying there are only three elements in the mechanics of putting a painting together—drawing, value and color. In other words: Where is it? How light or dark is it? What color is it?

Three other elements, namely conception, composition and technique, are important yet less concrete. We will deal with these also.

In this first section of keys, we will concentrate on drawing that includes not only accurate recording of items but also composition and design.

You are going to spend many hours applying paint to your canvas, but the result can be disappointing if the initial drawing is not correct. Designing is drawing, for not only should things be drawn well, they should also be placed correctly within the confines of whatever canvas you are using, be it 8″ × 10″ or 30″ × 40″. More paintings are spoiled in the first few minutes by the beginner who is so anxious to paint that he does not take the time to scale and compose his canvas correctly. With drawings, watercolors and pastels, which ultimately have a mat around them, the composition can be cropped a bit here and there, but with an oil painting, it is different—you are usually stuck with the decisions you make initially.

You do not have to draw in great detail at the composition stage—all you really need is a careful consideration of where the big areas are going. The detailed drawing is then gradually incorporated into the painting in each successive stage of its development.

I can't overemphasize the importance of drawing. I compare drawing in painting to syntax or grammar in writing a novel—when you can do it well, it frees you to concentrate on the story. Thus, in order to concentrate on color and the more aesthetic phases of picture making, you must be able to draw well. You can learn to draw if you're persistent and practice. Don't be like many painters, who are so busy making pictures that they can't go back and develop the basics that will enable them to make the finished product better.

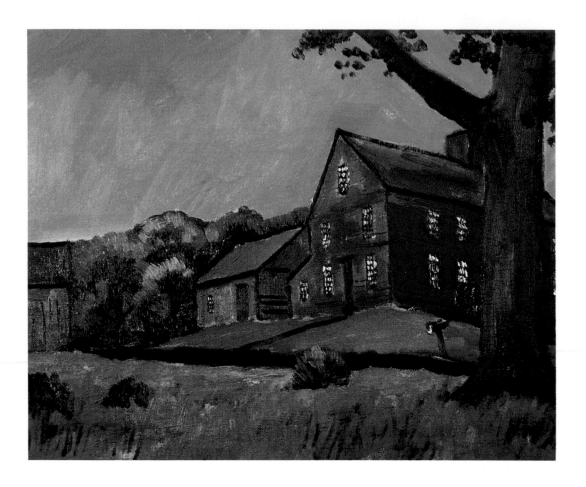

PROBLEM

Nature doesn't always design things to fit and balance well within the dimensions of your canvas. In fact, you're doing well to find subjects that are 75 percent ideal. Your taste and selection can take over and improve them. There are some basic rules for composition, but a great deal is just felt: The picture must *feel* balanced and not be too heavy on any one side. We must adjust unfortunate alignments and try to introduce a pleasing design of lights and darks. Unless you have to make a faithful rendition of the subject, do not hesitate to even move objects around, for your main concern is to come up with a good painting rather than record of the place.

This painting needs a bit more creative redesigning,

as you can see. It is too heavy on the right side because both the large house and the big tree are on this side. The roof line of the barn in the middle of the picture coincides with the house at an unfortunate point, giving us a repetitious design between the barn and the lean-to shed attached to the house. The distant tree line terminates at the barn roof on the left, and the road repeats this thrust to the left below; both lines sweep us out of the picture. I'd like to make a point here about chimneys because most students don't think enough about how they are constructed. Chimneys often straddle the roof ridge—they do not always sit on one side of it.

Summer in Rixtown, 20" × 24"

SOLUTION

By taking artistic liberty and redesigning this composition, we have taken the subject out of the realm of the ordinary. The big tree was moved to the left side and given a bit of rhythmic curve and flair. As a result, our eye now enters the picture in the lower right area by the mailbox. Because I kept the foreground entirely in shadow, we sweep up the tree and the limb carries us across the top, where we come down the corner of the big house and back over to the center of interest. Here I introduced a figure working by the barn. The design forms a veritable spiral that keeps our eye continually going into the picture and never leaving it. I moved the barn over to avoid the unfortunate alignment with the house and accented the center of inter-

est with the dark tree shadow falling on its roof. Now I have a climax (discussed in Key 19) to play the figure against. I changed the road to dirt and splashed sunlight over it; by introducing a bush in the foreground, I broke the parallel lines formed by the road. Finally, I included a hill in the background, which gives us a line flowing into the center of interest, and the lights and darks in the sky, which now form an interesting counterthrust. When you make a painting, it should be the most artistic rendition you can possibly come up with. Give more thought to re-designing where necessary, and see if you can't achieve a much more artistic solution.

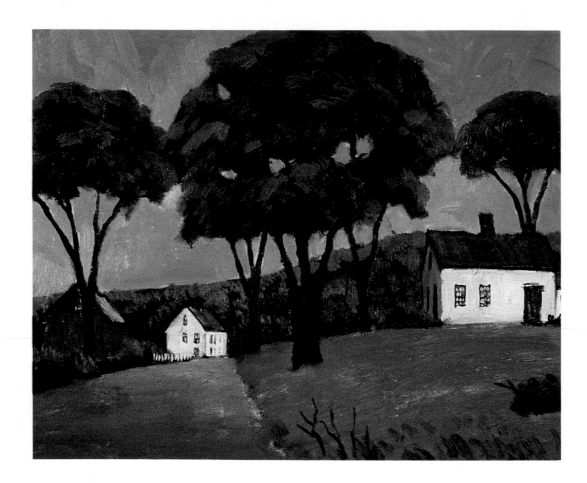

PROBLEM

Many times, more than one area will present itself as a possible main theme or center of interest for your painting. But resist the temptation to put more than one center of interest in your composition. This is a common mistake among beginners. It is almost like depicting a fork in the road and making each vista equally interesting. If there is more than one center of interest, make more than one painting. Feature one and subordinate the other in each instance, but never crowd both into the same canvas.

In the painting above, each half could become an independent and interesting painting. The large foreground tree has unfortunately been placed directly in the center of the composition, and the remaining trees are placed in an uninteresting design. (All painters have a subconscious tendency to revert to symmetrical design and repetitious shapes.) Notice also the way the line of the distant hills repeats the line of the grass and road below.

For some reason, students revert to what I call lollipop trees. They cannot seem to see and render the beautiful individual shapes and designs in front of them. Also, they do not seem to realize that limbs have to taper and become tiny twigs as they grow away from the trunk.

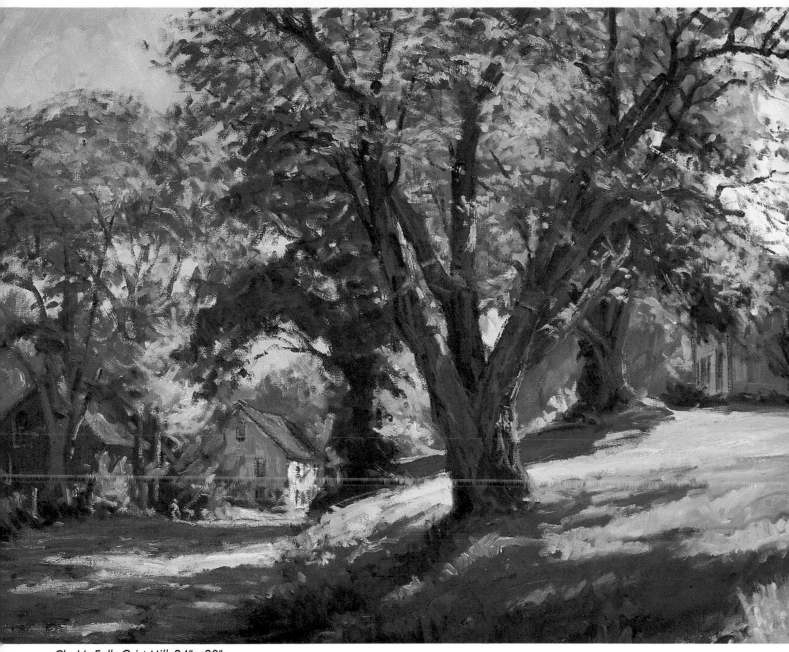

Clark's Falls Grist Mill, 24" × 30"

SOLUTION

Here we have practically the same scene and composition, but by shifting our attention to the section on the left, placing the big tree slightly off-center to the right, and playing down the house on the right, we have a much better composition and painting. I often caution my students, "Don't give them too much!" This is just another way of saying, "When in doubt—simplify!"

This composition is nearly the same as the problem composition—almost half road and half lawn—but notice what I have done here to make it tolerable. I first moved the grass line to the left and made it softer. Then, by

choosing a time of day that threw tree shadows over the area, I made the design and pattern of lights and darks more dominant than the design of road and grass. I like to drive on paved roads, but I dislike painting them. I invariably make them dirt—doing so not only adds to the charm and rusticity of the scene, but enables me to introduce warmth in an otherwise green painting.

Except for the tree behind the white house on the right, we still have the same placement and design of trees as in the problem painting, but see how with skillful, soft handling they are now beautiful rather than bothersome.

PROBLEM

Some teachers tell their students it is not necessary to draw well in order to paint. But they are only fooling themselves or their students, for unquestionably, the better you are able to draw, the better you will be able to paint. In this key, I want to show you another example of how your mind can dominate your ability to *see* correctly.

I have had many students out for classes at this lovely old farm not far from where I live. I can guarantee that at least 80 percent of them incorrectly draw the farm buildings as you see in the sketch above, and here is the reason why.

Most of the time, the buildings that we see are on the same level as we are and *not* above us, as in the painting on the opposite page. When we view buildings on the same level, our eye level, if projected to the building, would come to rest somewhere in the lower part of the first-story windows. As a consequence, the bottom (foundation) lines go *up* and *away* from the near building corners, as you see here. However, if the building is *above* our eye level, the bottom (foundation) lines go *down* and *away*. Beginners tend to rely on subconscious knowledge and persist in drawing as though the building were on the same level, rather than above eye level. When the painting is finished, they wonder why the house does not look like it is up on a knoll as it is supposed to be!

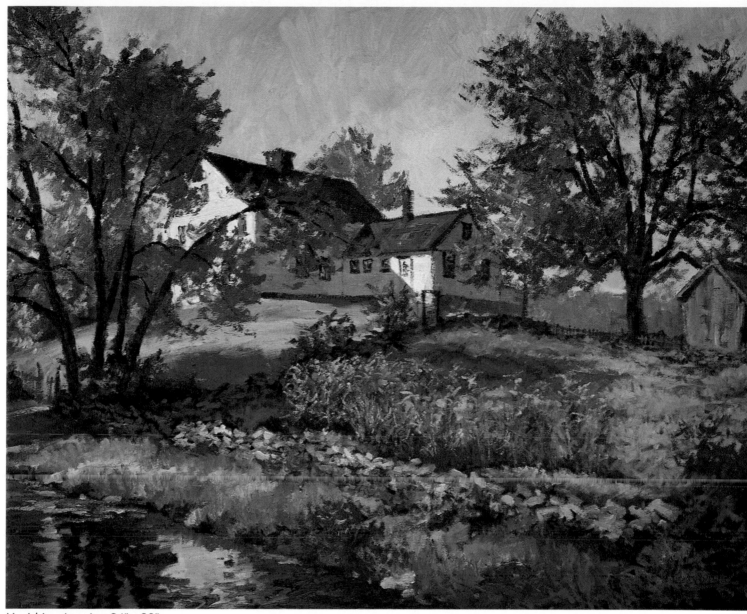

Vanishing America, 24" × 30"

SOLUTION

One can get very involved in the mathematical rules of perspective, but for the average painter there is a simple approach. There are only two things you should know— namely, where is your eye level and where are the near corners of the building?

To find your eye level, pretend you are shooting a rifle absolutely level. Then approximate where the bullet would hit. In our case, it would be roughly six feet below the foundation of the buildings. Now identify the corner of the building nearest to you. In this case, there are two adjacent units each having their own near corner. Now remember this rule: All horizontal lines above your eye level and going away are drawn going *down*; all horizontal lines below your eye level, going away, are drawn going *up*. In this case, because the entire structure is above your

eye level, all of the lines go down in each direction.

Most of the time, buildings are on our level, so the bottom or foundation lines go up. Since this is the case *most* of the time, students do it *all* of the time, as I have demonstrated in this key.

Another rule to remember while dealing with perspective is this: All parallel lines (like railroad tracks) have to converge as they go away from you toward the horizon or eye level.

Drawing is a combination of observation and knowledge. If our observation were perfect, we would not have to depend on theoretical knowledge. But knowledge tells us what *should* take place—then we look again and that's what it does. That is seeing analytically and accurately.

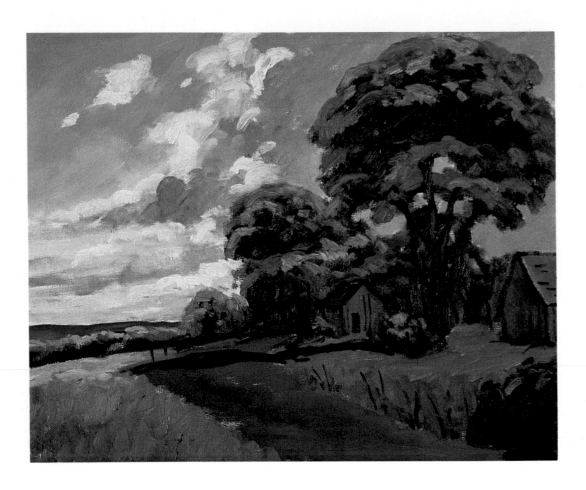

PROBLEM

The beginning student may not even think about a principle like this. The professional, on the other hand, is very conscious of this point. In a general exhibition, an artist wants to capture the attention of the viewer and hold it on *his* painting. He wants the viewer to linger long enough to savor and appreciate those passages he so carefully thought out and rendered.

The design of the painting above includes big directional thrusts. These are fine as long as they do not carry us right out of the canvas, as they do here.

The trees in this example line up from big to small, carrying the eye out to the left. The clouds repeat this directional thrust. Now, because the design of clouds on a particular day may be unfortunate, it doesn't mean we are committed to painting them that way. On a still life, we could go up and change the background drape to a more advantageous directional flow. Outdoors, we must redesign it on the canvas.

The tar road, painted literally, is rather uninteresting in color. It leads the viewer up from the right-hand corner, follows the tree shadow, and turns left down the line of the field and (with nothing to stop it) out of the picture.

Can you spot another mistake? To give you a clue, the red flowers on the bush in the lower right corner are much too spotty. Study how they are handled in the correct rendition.

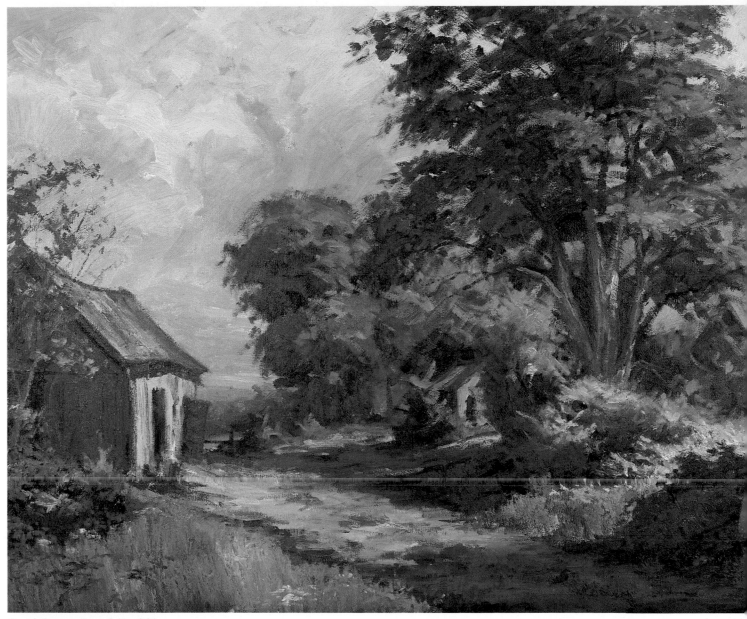

Rural Connecticut, 24″ × 30″

SOLUTION

When you have a strong directional thrust that sweeps the viewer's eye out of your composition, put a block there to stop the exit and turn the eye back into the painting. Here, I created a block by introducing a barn that was actually on the road behind me. (Just remember, if you are going to be a liar, you have to be a good one.) If you move things about, be sure to have the lighting consistent with the rest of the composition.

Notice the interesting design of the trees as opposed to the symmetrical ones opposite. There is a sense of sunlight and where it is coming from. See how I play the shadow side of the foliage of the big tree against the lights of the trees over the barn in the center, behind it? You will find definite patterns of lights and darks such as this one in all of my work. The shadow in the right foreground was not really there, but see how it increases the effectiveness of the dramatic light coming in from the right.

Making the uninteresting tar road into a rustic dirt one gave me an opportunity for better color. Finally, I have made an *interesting* sky, but it remains subordinate to the landscape. This subject will be discussed later in Key 46.

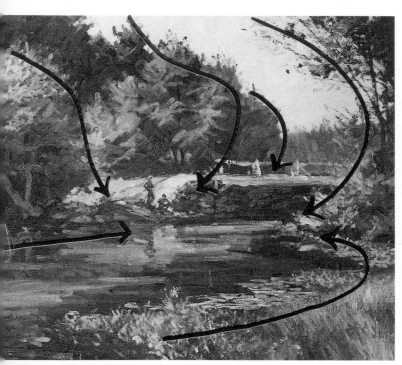

These directional lines show you how I guided the viewer's eye into the center of interest.

This is a photo of the actual location.

The knowledgeable artist tries to make viewers see what he wants them to see in his painting. In Key 4, you saw how I prevent the viewer's eye from leaving the painting. In this key, you will see how I guide the observer *into* the center of interest with directional lines of the composition. Sometimes these directional lines are large, sweeping *S* curves, and other times they are simply flowing, directional arrows, as you see here.

On this page, rather than showing you how *not* to do it, I made a black-and-white print and superimposed arrows right on it so the directional lines would be quite clear. These directional lines show you how I guided the

viewer's eye into the center of interest.

The composition presented by nature is not always ideal. You must give a lot of thought to the best vantage point to paint from, but even then, changes often have to be made. A distant hill line is reversed, a tree is moved, the composition is changed in order to utilize the principle shown here. The photo above shows you just what the scene actually looked like. Compare it with the finished painting at right. As you learn to control your subject matter, rather than having it control you, you will become master of the situation and will make better paintings.

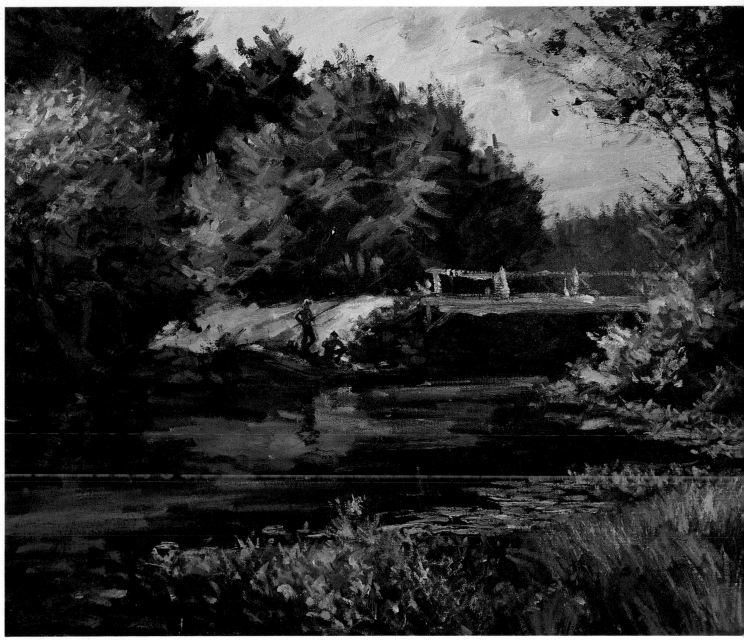

School's Out, 20" × 24"

Now study the painting without benefit of the super-imposed arrows and see how your eyes follow the same directional thrusts even in their subtle rendition. Whenever possible, I try to design the composition so that there is a dominant flowing line *into* the center of interest, particularly from the corners.

While we are viewing this painting, let me comment on it further. A point I shall devote a key to later is the introduction of figures into your landscapes. The eye and mind of the viewer respond to human interest, and here it gave me an opportunity to introduce some warm colors into an otherwise cool (blues and greens) painting. I go to nature so I can paint it more sensitively, but do not feel hidebound by what is actually there. I changed the rather ugly concrete bridge to a more rustic one and I left out the telephone pole. Notice how the trees and bushes on the right keep the big wedge-shaped thrust from the left within the painting. I added an extra dimension by opening up the area above the bridge. I like to see three basic planes in a painting: foreground, middle distance and distance. I'll go into this point further on in the book.

When in Doubt, Simplify Your Design

PROBLEM

Design in a painting concerns the pattern that the areas of lights and darks create, as well as the shape, size and placement of the objects themselves. An awareness of this factor and its introduction into your work might be the main step in the difficult transition from student to professional painter. I am constantly reminding my students that the design created by the play of lights and darks on the subject is aesthetically more important than the subject itself. When students first start to paint, they are quite happy to make a satisfactory record of the subject, but a painting should be much more than that.

In the above problem painting, we can see the result of the lack of an organized design. Faced with a subject such as this, the novice is overwhelmed by the thousands of leaves and fails to realize that out of them he must organize a pleasing design. I have kept the basic design of the subject matter much the same as in the solution painting, so we are dealing primarily with the design factor of the lights and darks. Because the student is not aware of this important element, it usually does not exist in his work, as you see here. There are just many, many clumps and bushes, the contrast is flat and uniform, the shapes and spaces are repetitious, and it is all handled in much the same manner. The result is a very monotonous and spotty picture.

Quiet Brook, 30" × 36". Courtesy of Mr. and Mrs. Arnold Hartikka.

SOLUTION

In my paintings, I like to see the elements of harmony and order. The picture should be well organized, not hectic and chaotic, and the painter can bring about organization primarily by a well-planned design. As I explained on the opposite page, the design element relates to value patterns as well as to subject matter. I dislike rules in painting, but one I often repeat is this: When in doubt— simplify.

Some of the aesthetic concepts of a painting are difficult to put into words for the student—they almost have to be felt rather than specified. One way I attempt to explain this principle is that some areas of a painting have to contain more darks than lights, and other areas more lights than darks. This takes place even in a simple study

of a single tree. Many times several possible solutions present themselves, and I merely caution the student in a negative way: "Be sure *not* to get your painting spotty." Before you begin to paint, you must sense a definite pattern and design that will hold your painting together, and stick to it no matter how the light actually changes while you are working. This solution can be part factual, part imagined. The only rule I stick to as I depart from the literal is that "it *could* have happened that way." Dealing with elusive items like patterns formed by the trees and bushes above is not easy, but I trust you can see how the introduction of a definite and organized design has made this a painting instead of simply a record of the subject.

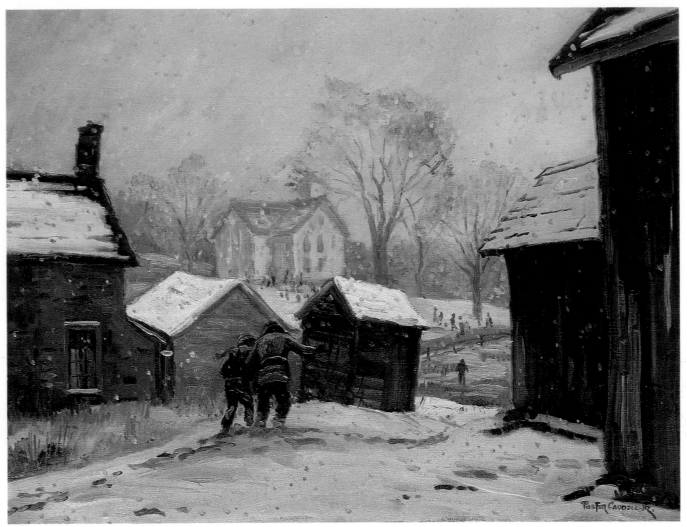

The Center School, 22″ × 28″. Private collection.

A well-conceived and well-placed figure can do so much for a painting. Place a finger over the figures in the scene above and see how it looked before I added them. That is how I saw the scene that snowy Saturday many years ago. I wanted to depict a vanishing part of America—the old Center School, which dated back to Civil War days. As I studied it, the part that seemed missing was the kids trudging through backyards and fields on their way to classes, urged on by the tolling bell. This was an era long before the coming of our slick, yellow school buses. Yes, the missing ingredient was the children. So, the next day,

on Sunday, I put the figures into the painting. I tried to imagine how they would trudge through the snow, collars up, mufflers blowing, as they talked of most anything except the lessons that lay ahead. I feel I captured the mood and spirit of the subject, and the painting became much more successful and meaningful because of the figures.

Students very seldom put figures in their paintings, and when they do, the figures are usually poorly drawn, like stick figures.

Let me relate to you an interesting incident concerning this painting of *The Center School* made many years

Here are close-ups of some of the figures I have used in my work. By taking my ideas and inspiration from real people, I get a greater sense of authenticity and reality. Usually, someone is walking about or engaged in some activity while you are painting. Make sketches of them if you cannot paint them in directly on the spot. Note that my figures have movement and action— they "feel" as though they are walking or doing something. Most students make their figures too stiff and rigid.

ago. It was a sparkling, sunny morning, and I had anticipated for some time painting this scene with snow on the ground. I had barely gotten the composition sketched in when the sky grew ominous. I soon found myself sitting in the middle of a snowstorm with the snowflakes falling on my canvas and palette. In those days, I had less time to paint, so I was determined to continue, inasmuch as I was all set up and underway. From my car, I got out a large beach umbrella that I always carried, set it up over me, and decided that I could be as stubborn as the

weather. The blowing snowflakes mixed with my paint and even got on the canvas. I decided philosophically that I would at least get an authentic study of a snowstorm that I could copy later.

More than forty years have passed since that incident, and the finished painting (opposite), showing absolutely no sign of deterioration, is part of my permanent collection. Perhaps there is a moral to this story—if you are ever to succeed as a painter, a very important element is dogged determination.

PROBLEM

Before you start a painting, decide what the reason is for the particular work. What are you trying to say? It may be: "It's a crisp autumn day—wonderful to take a walk," or in this case, "a lovely quiet day for drifting along—fishing one's favorite stream." That lucky chap putting his canoe in the water is the center of interest and depicts the main story in this picture.

In the problem version above, too many conflicting statements divert the viewer's attention. First, the canvas is divided into thirds and too much space is devoted to the sky. Just because there are stark white clouds against a blue sky doesn't mean you have to paint them literally if they don't go with the rendition of the subject. Also,

they are too repetitious in size and design. Remember, it's all right to change things if you know *why* you are doing it and *what* it will accomplish. One of my cardinal rules is: "It must be possible—that is, it could exist in the way you alter it."

When every area is crying for attention, the viewer's eye is hopping here and there and never settling in any one section. Many times, in my work, when the center of attention is in the middle distance, as you see here, I throw the foreground into shadow. Often, it doesn't happen literally on the scene, but it *could* have happened. By reducing the lights in this value range, the foreground becomes less competitive.

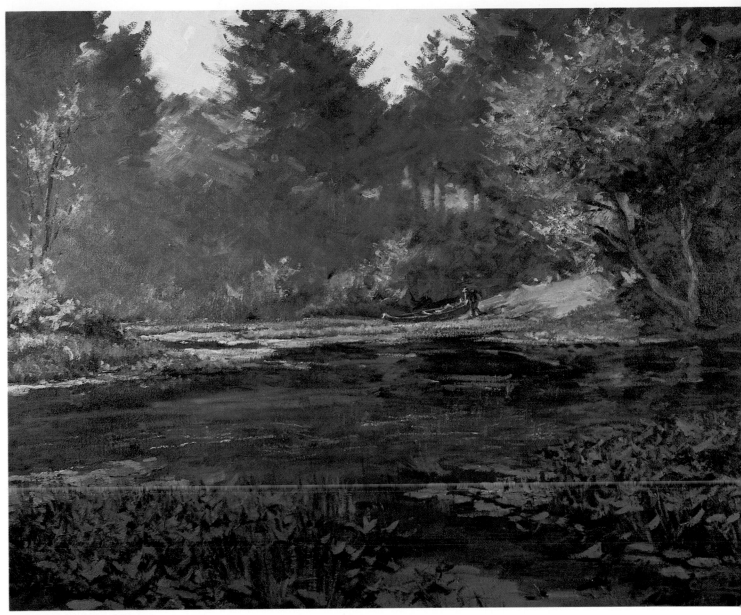

Goin' Fishin', 24" × 30"

SOLUTION

This is a better painting primarily because I played up what was important (and what I wanted people to see) and subordinated the rest. When students first go outdoors, they are overwhelmed by the magnitude of the vast area, and the thousands of leaves, weeds and grasses that confront them. A good rule to remember is this: "When in doubt, simplify." Don't give the viewer everything. The main thing here is the chap putting his canoe into the water. Not only did I group lights and darks together in this area, but I also made the canoe red—a definite attention grabber in an otherwise green painting.

The sky area is minimal, and its luminous effect is created by superimposing the same value of the three primary colors, while they are still wet.

I used the morning fog to simplify the entire far bank of trees, and I kept the detail, most of which is on the center of interest, on the illuminated areas. I did go into detail with the weeds and grasses of the foreground. However, I purposely kept them in shadow to help the viewer get beyond them into the painting and on to the center of interest. Study how I only suggest the weeds around the canoe, dragging cool colors over warm ones. The viewer's mind will see all the weeds even though I haven't done them in as much detail as in the foreground.

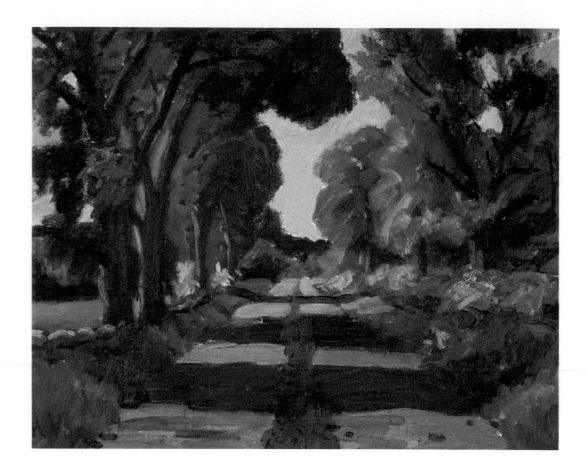

PROBLEM

In general, beginning painters revert to symmetrical, uninteresting solutions to most problems, and roads are no exception. Here the road is in the exact center, and the spaces on each side are almost equal. Also, in an effort to make roads go back, the student often extends them too high in the picture. For aesthetic reasons, and also as a way to introduce warm colors, I usually convert tar roads to dirt, but this necessitates knowledge and taste. The edges of a road without tar are soft, and the grass that often grows in the center is irregular—things students may not think of. The color improvised here is bad, and the design of the shadows rigid and parallel to the thrust of the road and bottom of the canvas.

Along with these main problems, let me point out some other common mistakes. The sky is flat and just blue. There is not enough aerial perspective—notice that the distant hills and trees are painted the same color and value as the near ones. On the right side of the road, an exaggerated effort has been made to explain that these are trees with trunks rather than simply a pleasing abstract design that only happens to be trees. The stone wall and trees on the left are repetitious in shape and design. The usual color problem in a summer picture exists here—a lack of colors other than green.

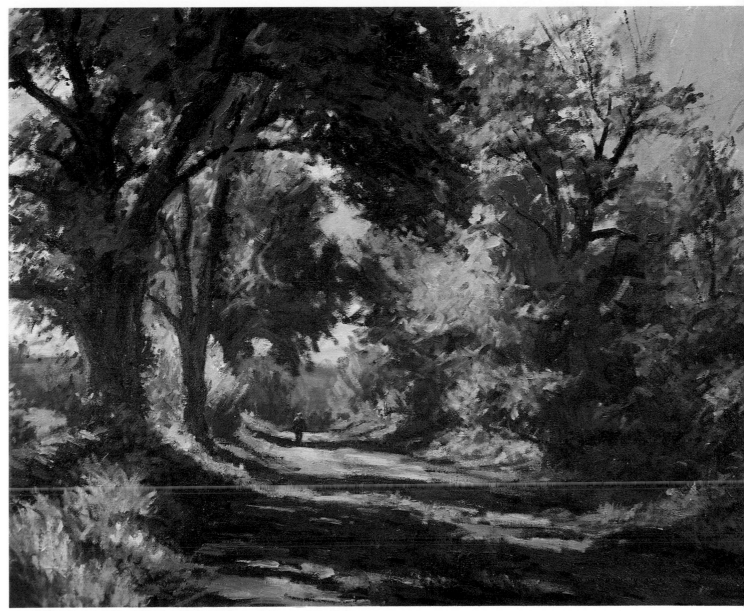

The Valley Road, 24" × 30". Courtesy of Mr. and Mrs. Loring Bailey.

SOLUTION

With the road off-center, I now have a much better design. Also, the shadows across the road have a pleasing diagonal thrust and the design of the road itself becomes subordinate to the decorative design of the shadows and lights running across it and over the adjacent foliage. A good painting always has a very positive design of lights and darks that has been achieved in a soft way. The road is now actually lower than the field on the left, which is the way the scene really was. The indication of a figure walking in the road gives us a sense of scale and brings our eye into the center of interest.

The dark mass of foliage at the top overlaps the light tree on the right rather than just touching it. I have painted the sky lighter near the horizon and to the left where the source of light is. Notice the colors other than blue in the sky. The distant trees and hills become an atmospheric blue-green because of haze, thus giving a greater feeling of depth. There is diversified color in the greens now. Note the color I have used in the grapevines on the right and in the dead leaves and debris that washes along the edges of the road. Notice, also, the beautiful blues and purples of the sky that are reflected in the shadows on the road. We must take every opportunity to see, feel and use beautiful color.

Make Tree Shapes Varied and Interesting

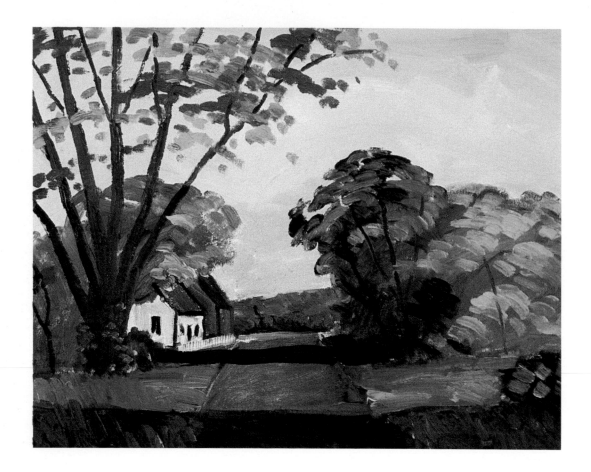

PROBLEM

It is hard to paint landscapes and not know how to deal with trees, yet this is one of the major stumbling blocks for many painters. Probably because trees do not have positive shapes like buildings, the novice finds it hard to be specific about them, and consequently, usually reverts to using a very uninteresting, monotonous shape. This is a result of not being able to see, analyze and paint beautiful shapes and patterns that just happen to be trees.

When you have trees in your painting, deliberately try to vary their shapes and sizes. If you don't, chances are you will tend to repeat shapes, as in the demonstration above. I frequently say to my students, "Paint trees so the birds can fly through them." All too often their trees are much too solid and heavy. I encourage my students to make studies of individual trees to become familiar with the great variety of shapes of designs. Once you have a thorough knowledge of trees, they will take their place in your paintings as things of graceful beauty.

In this problem demonstration, the sky is painted too light and hinders any effect of brilliance in the foliage. The bare tree limbs are spread out evenly, like a fan. The road is not wide enough in the foreground, so it appears to go uphill. The shadow patterns across the road are too rigid and stiff, and obviously there is not enough contrast to say "sunshine."

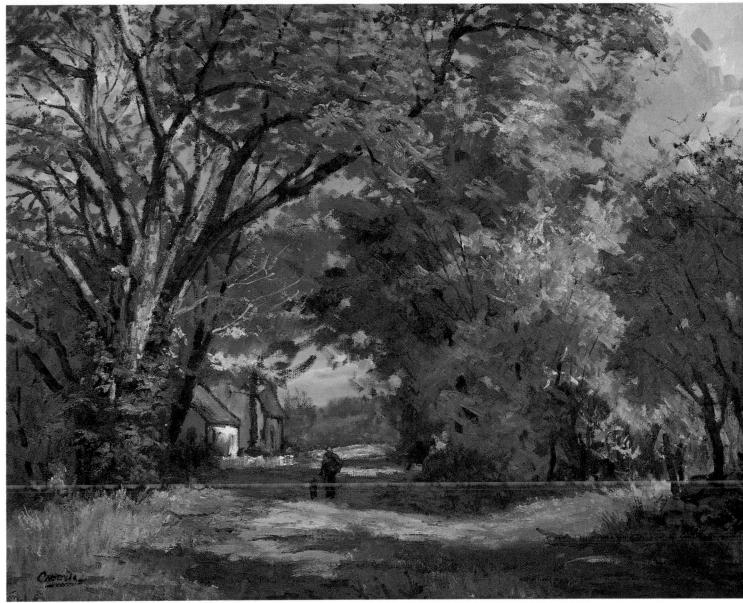

Autumn Splendor, 24" × 30"

SOLUTION

The masses, patterns and colors in a subject like this are really an intriguing abstract design—a design that only happens to be trees. To achieve definite shapes and patterns in a soft, flowing way—so that we almost feel the trees moving in the breeze—is not easy. It requires study and practice.

Notice the soft sensitivity with which the foliage of the big tree on the left is handled. Because the value of the sky has been held down a bit, the sun hitting the foliage really sparkles. The sun also sparkles on parts of the rough tree trunk, as the result of a strong impasto painting over a dark underpainting. The poison ivy climbing up the

tree is now a brilliant passage of color.

Notice that the trees really flow together—they don't have to remain isolated, individual objects. The road, which is wider now in the foreground, lies flat, the way it should.

The sun splashes across the road in an interesting design. The small trees on the right were brought into the composition to dramatize the light behind them.

The final colors we see in this painting were achieved by painting color into wet color in many instances. I waited for the undercolor to set up and dry, when I wanted a sharp, specific statement.

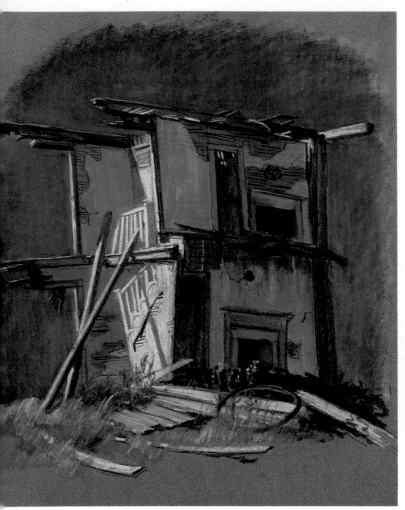

Study of Old House, Pastel on paper, 20″ × 24″

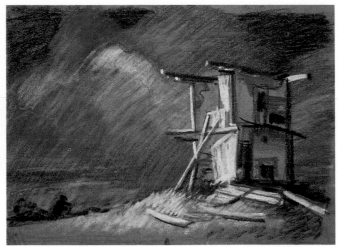

Here is a rough, comprehensive study in pastel that I did before I started the final painting.

This key is a bit different from the others, inasmuch as I am not showing you something done *incorrectly* on this side. What I would like to stress here is the worth and importance of carrying sketching materials with you — and making use of them. Too many inexperienced painters are so concerned with making paintings that they overlook the importance of gathering information and knowledge by means of sketching. The pastel study above left was done several years ago, on the spot, not pretending to be a great work of art but merely a fact-finding study. I discovered the subject while driving through a nearby rural area. The remains of the old house fascinated me. It had almost completely decayed and collapsed, but the core of the house was still there, and flowers bloomed around the base. It was almost as if the heart of the home would not die. For those of you not familiar with early colonial construction, an explanation here might help. In larger houses, the chimney, a massive stone structure, was the core of the building. Each of the fireplaces fed into it, and the hand-hewn beams attached to it. That is the reason this fascinating structure was still standing — the part that was tied into the stonework remained as a reminder of the past. This sketch was done on toned paper with Nupastels. For more serious work, I prefer softer pastels, but I had these in my sketch kit at the time.

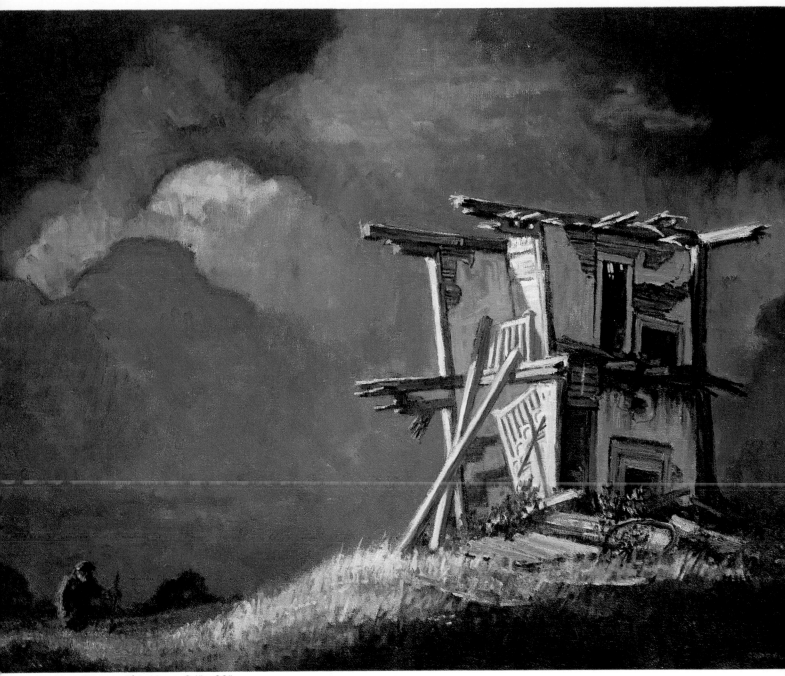

How Dear to This Heart, 24" × 30"

The above painting is rather unusual because I do almost every painting on location, and this is one of the exceptions. The pastel study hung around the studio for some time. It stirred my imagination, and I wondered who had lived in the old house. Perhaps it had been some young couple's first home, the place they raised their family. I thought of the tales it could tell of a bygone era if it could but talk. I recalled an oft-repeated bit of advice—do not try to recapture the fond memories we have of a time or place of long ago by going back to it, for it is often no longer as we remember it. Finally, these thoughts prompted me to turn the study into a painting of a symbolic old man returning to the scene of a happier time and surely regretting that he had done so. A special sky had to be felt and visualized to enhance the mood I was portraying—an emotional experience like this one could not happen on an ordinary, clear, sunny day. The title that seemed just right was the first line from the old favorite song of yesteryear, "The Old Oaken Bucket": "How dear to my heart / are the scenes of my childhood / When fond recollection presents them to view." Rather ironic and bittersweet, but so apropos.

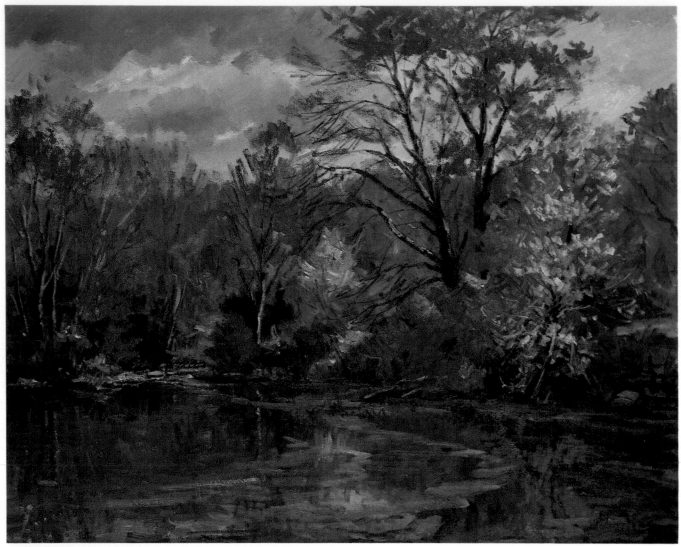

Autumn Reflections, 20″ × 24″. Courtesy of Dr. and Mrs. Carl Conrad.

EXAMPLE ONE

Here again I am departing from the basic structure of the book of showing you a "bad" example and a "good" example of a painting. These two paintings are both "good" examples of how to depict the beautiful patterns of nature. The longer I paint, the more I feel that design is important in a painting. I treat design like the grammar structure of a sentence. It is important that correct structure be there, but there is no reason the sentence cannot also *say something.* That's why there is subject matter in my work that the average viewer can appreciate even though they may not be aware of the design aesthetics that I also incorporate.

In making a painting like the one above, you must first plan exactly how you are going to render it. Because the trees are so lacy, you must deal with the background first. You have to decide how to treat the sky, which takes up a third of the canvas. I decided that the sky should have cloud shapes because it was too big to remain plain — but the shapes should not compete with the landscape. I took advantage of cloud shadows for color and value, and I made sure that no light portions were as light as the ones I would put on the trees later. I also underpainted the background trees. On top of this, it was all pure design. Except for the few tree trunks, I just painted the beautiful shapes and colors that appeared to be trees.

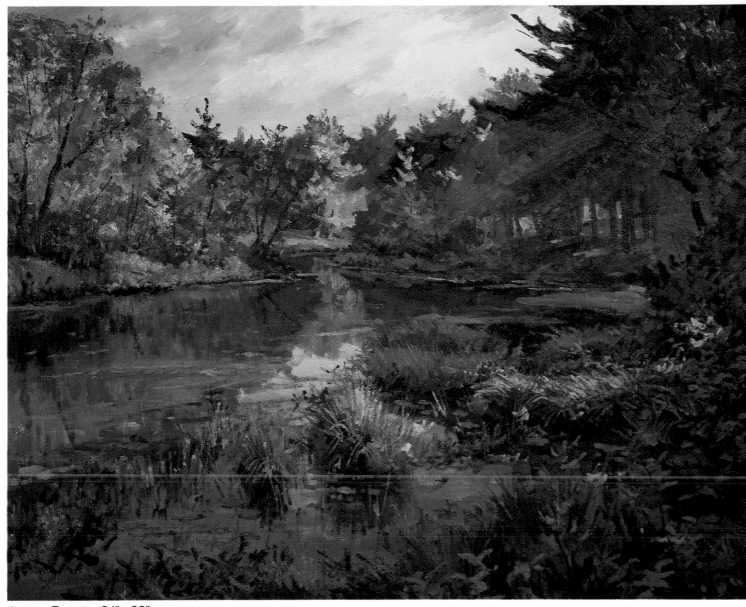

Autumn Tapestry, 24" × 30"

EXAMPLE TWO

The average student may find this type of subject matter hard to cope with. You must be able to look at a subject like this and see not only design and patterns of color, but also the big design that is created by the play of light on the scene. This makes it more difficult because the sun does not stay still, and the patterns of values change constantly. The secret is to fix a desirable effect in your mind the first time you see it, and continue to paint it that way even after it has changed.

In painting a scene like this, I do not like to see the reflections rendered as vividly and crisply as the landscape above it. Therefore, I keep the water agitated enough so the two images are not competing. Reflections actually have a shorter value range than the objects they reflect.

Nature is always harmonious. I like a fall scene that has a lot of green in it. It enhances the effect of the brilliant autumn foliage.

At the risk of being repetitious, I must reiterate this point: The ability to paint a scene like this comes from many hours spent studying still lifes. You must have enough analytical ability to read the passages in front of you—whether it is a paisley shawl or weeds in a stream. It all comes down to being able to match any color and value, and to draw shapes and patterns. If you are skilled in these areas, your canvas will look like the subject—no matter what it is.

Vary Your Solution to the Same Subject

Autumn at Phillips Pond, 24" × 30"

EXAMPLE ONE

One of the desirable qualities of an original piece of artwork should be its uniqueness; there should *not* be another like it. I am afraid this is not always the case. While casually walking around after serving as a judge at an outdoor art festival, I observed that just as a woman walked happily away with her new acquisition, the artist who sold it to her went into his van and came out with an exact duplicate. This practice is highly unethical (although the artist is unwittingly cheating himself as well as the purchaser), and it is also unnecessary. Without duplication, the same scene can be painted in different seasons, with different lighting effects, or with conditions practically the same but a different mood.

In this key, I want to give you two examples of how to vary your solution to the same subject.

These two paintings were done at what I call my "Walden Pond." This is a delightful spot, a few miles back into a state forest near me, where I have spent many hours painting nature in its many wonderful moods. Each is a good example of a big division between areas of light and shadow. See how I have placed a simple darker passage adjacent to where I play the lights. The island on the left is a good example. See how many more key solutions you can find in both of these examples.

The Visitors, 24" × 30"

EXAMPLE TWO

Here is the same spot at a different season. Sometimes a "green" summer painting is more difficult to do because of the limited color available. Here I have taken advantage of the foreground covered with the old pine needles to introduce a welcome warm relief from the overall green.

Instead of a human figure, I have introduced some deer as the center of interest. Study how I have played lights against darks, not only on the deer, but also throughout the composition. To make a flat canvas appear to have space and air, as we see here, is accomplished by the correct values and color. We shall go into that more

in the next two sections of the book.

Early in my career, I met a wonderful, elderly Italian painter, who had a poetic way of explaining things. It was he who taught me to "take the same meat and cook it in different sauces." Now I pass this on to you. I trust that, as you study these two paintings, you will see that there is no need to turn out paintings that are repetitious, hack work. In fact, if it were not for the marvelous challenge that art provides, and the inner satisfaction of meeting that challenge and conquering it, I would not have devoted my life to painting, and as a consequence, would not have written this book for you.

PROBLEM

In explaining to new students in my class that they must first learn to *see*, I often emphasize that I will teach them how to look for beautiful colors and patterns in commonplace things. In this problem painting above, the painter lacked not only the sensitivity to appreciate the beauty of the weeds in the foreground, but also the ability to paint their beauty.

Failing to hold the direction of the sun off to the side and selecting the time of day when the sun was directly overhead made this scene less interesting. The buildings look flat, and there are no lovely cast shadows playing across the ground. With nothing on the right side to stop it, the viewer's eye is directed right out of the painting. The tree in the center is not only placed right in the center

of the shed, but is also much too symmetrical. A good rule to stress here is: Don't leave objects like this just touching the edge of the canvas. Either keep them well within, or let them flow out, as you see in the solution version.

The sky takes up too much canvas to be left so plain, and the greens are too much the same color and value. All the weeds, leaves and flowers are handled with the same repetitious, spotty strokes. The stones in the wall are all the same size and color. The stone wall back by the shed is made up of separate stones. There should never be this much detail that far back. When you squint your eyes and look at the whole scene, you don't actually see individual rocks back there.

48

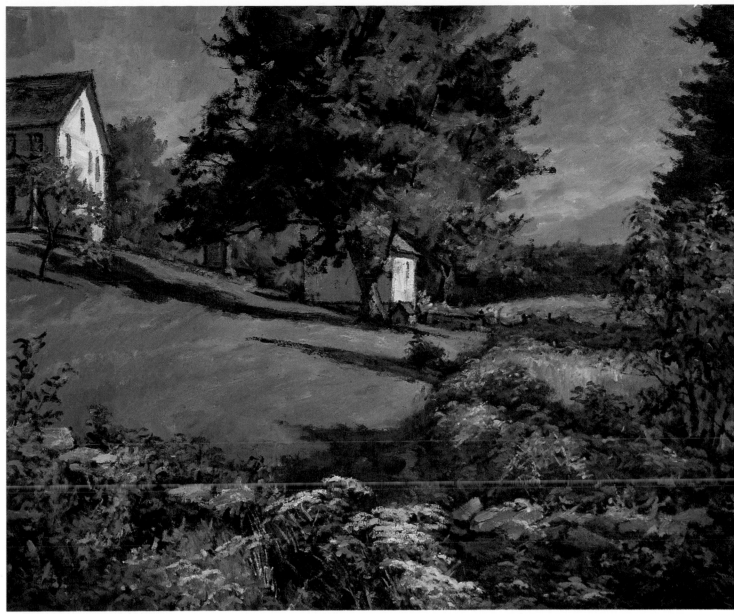

The End of Summer, 24" × 30"

SOLUTION

This is a wonderful old farmhouse near my home. I have painted it from nearly every angle—you will find other versions in this book. Note the lovely weeds in the foreground. Someone once said, "Weeds are flowers whose virtue has not been realized." To me, a field of ordinary grasses and weeds can be as beautiful as an Oriental rug, and that is the way I have rendered them here. I do not often have the main attraction in the foreground, but here the farm buildings and trees in the middle ground play a subordinate role. Even the sky is played down; however, it is dark enough for the light on the house to register against it. There is also a slight diagonal flow to the soft cloud design complementing the angle of the wall in the

foreground. The subtle purplish color in the cloud shapes repeats the more positive color of the joe-pye weeds in the foreground. I placed the distant hills in cloud shadow so I could paint them dark and hold them down. The big fir tree and bush on the right were brought in closer than they actually were to prevent the viewer's eye from sliding out of the picture.

I kept the sunlight off to the right to illuminate only one side of the buildings, thus giving a greater feeling of solidarity in objects. I have also given a great deal of thought and planning to the cast shadows as they travel across the field and up the hill.

Detail from *The White Mill*, 16" × 20"

Light and Tonal Value

In this section, we shall take up the subject of light, and I am sure you will begin to appreciate its importance even more than you already do. In our daily lives, light is all around us enabling us to see, yet we are hardly aware of its source and function until we try to put it into a painting. We must be aware of two sources of light—the direct rays from the sun and the soft top light from the sky.

The presence of light in your painting can be ordinary and uninteresting, or it can be exciting and dramatic, as it bursts into your canvas from a certain angle and flows across objects creating form and shadow patterns. I am very conscious of what I term the *drama of light*; it has always had a strong appeal and fascination for me, and I have long admired it in the work of the Old Masters who used it so well, like Rembrandt and Caravaggio. To me, the patterns created by the drama of light on a subject are just as interesting as the subject itself

I seldom see a student make the mistake of using too much light in his work. Most are hesitant to exploit its possibilities, so they end up with a rather flat painting that does not convey the feeling of sunshine. They do not seem to be aware of this while they are painting outdoors, but then are disappointed when they take the canvas indoors where it seems to go dead.

Let's explore how to use lights and darks strategically in your work to help you capture the beauty and sparkle of nature.

PROBLEM

This problem is one of the major failings of all beginning painters. The longer you paint, the more you will be as conscious of patterns of light and dark on the subject matter as of the subject matter itself. Here the subject is an old mill house in my village. As you can see, without strategically planning a design of lights playing against darks, we have a rather flat, monotonous painting.

Many times, in my early painting career, I would see subjects that I thought would make a great painting; however, lacking the time or necessary materials, I would promise myself to return another day. Upon my return to the spot, I would wonder what I had been so excited about. You see, I failed to note what time of day created the lighting that had made me so enthusiastic about the subject. You can readily see in the painting above how the *wrong* lighting can make even an interesting subject rather unappealing. When everything is illuminated and high-keyed, it all shouts for attention. Never depend on just colors registering against each other; always play lights against darks.

Notice that in my problem painting I did not use a figure in order to demonstrate how much more interesting the solution painting is by the inclusion of one. I talk more about this subject in Key 7.

Emma's Place, 23½" × 26½"

SOLUTION

You can see how much more effective this subject is with light coming from the left rather than from the right. I took the liberty of making the value of the sky darker than it actually was, thereby keeping the focal point on the lower part of the painting. The dramatic contrast of the dark side of the lilac bush on the left creates a foil for the play of light on the weathered boards of the old house. The exact opposite happens on the right side of the picture, as the dark side of the house becomes a foil for the lights on the lilac bush in blossom. The strong diagonals of shadow pattern in the foreground help the overall design; they also limit the amount of light in the picture, making the remaining lights much more effective. The lights on this painting are not brighter than on the problem painting, but see how much more important they are played against darks. Old Emma, a hearty New Englander who lived alone in this old mill village cottage, brought me out a piece of mince pie she had just cooked on her wood-burning stove. I could not resist putting her in.

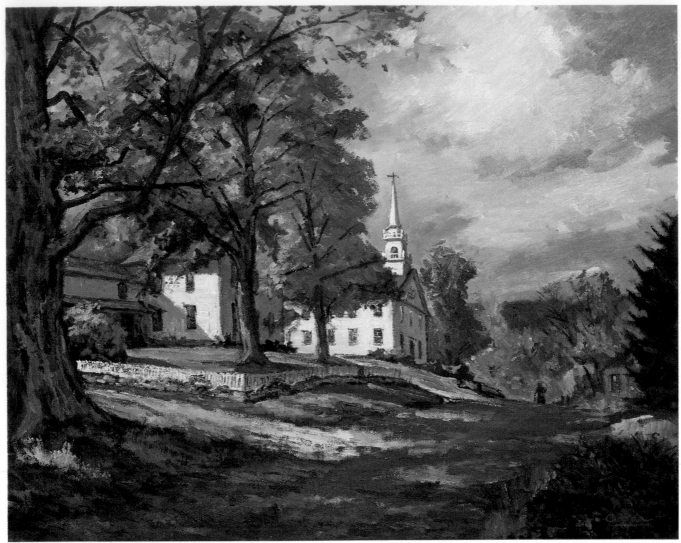

Rural Connecticut, 24" × 30"

EXAMPLE ONE

Without light, we could not see anything. The presence or absence of light makes objects lighter or darker. The simple term for the lightness or darkness of a color as it is influenced by surrounding light is *value*.

I have seen so many students struggling with their work and complaining, "I don't know how to mix that color," yet they haven't figured out what *value* it is! I cannot overemphasize the importance of value. If you get the value relationship correct in your work—even if the color is a bit off—you'll have a good, solid piece of work. Naturally, it is your ultimate goal to achieve both simultaneously. But you must know how you are going to register each passage on a value scale between the lightest light and darkest dark *before* you begin to paint.

I am using two similar subjects here to demonstrate

my point. We are all familiar with the typical colonial churches with white steeples. But don't let what you know prevent you from painting them correctly, that is, under the prevailing lighting conditions.

The center of interest in this painting is, of course, the church. The steeple in this case is mostly bathed in light. Notice how I have designed the sky behind it so that it is a middle value—darker than the light side of the steeple, and lighter than the dark side. If the steeple is the star, we want to hold down the competition. So even though there are dramatic cumulus clouds in the sky, they are not painted as light as the steeple. The general design of the clouds leads the viewer's eye down toward the center of interest.

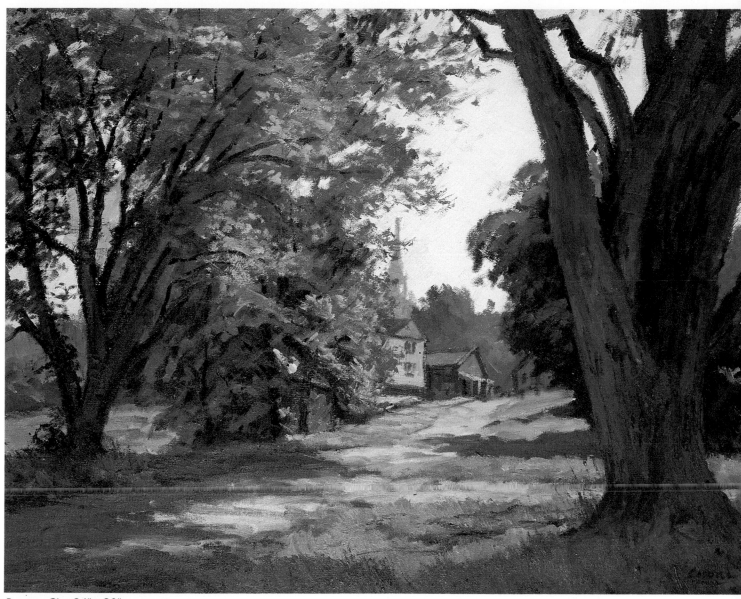

Preston City, 24" × 30"

EXAMPLE TWO

Here we have a church of almost the same design and size, but the white steeple is not painted white. When we are looking into the morning sky, the white steeple is actually darker than the sky behind it. Because we are dominated by what we know and what we see, we may not be able to bring ourselves to paint it correctly.

This lighting condition is known as *backlight*. I shall devote a key to this later because it offers such interesting picture possibilities. As you render every passage in a painting, you must ask yourself, "Why do I see it?" not "What is it and how do I paint it?" I can't stress enough how important values are. In all my work, I place a great deal of importance on the *drama of light*.

Notice that the red building to the left of the church (actually an old blacksmith's shop) is suggested by just a few brushstrokes. The trees, although handled freely, should be constructed well enough so that a knowledgeable person could recognize what type of tree it is.

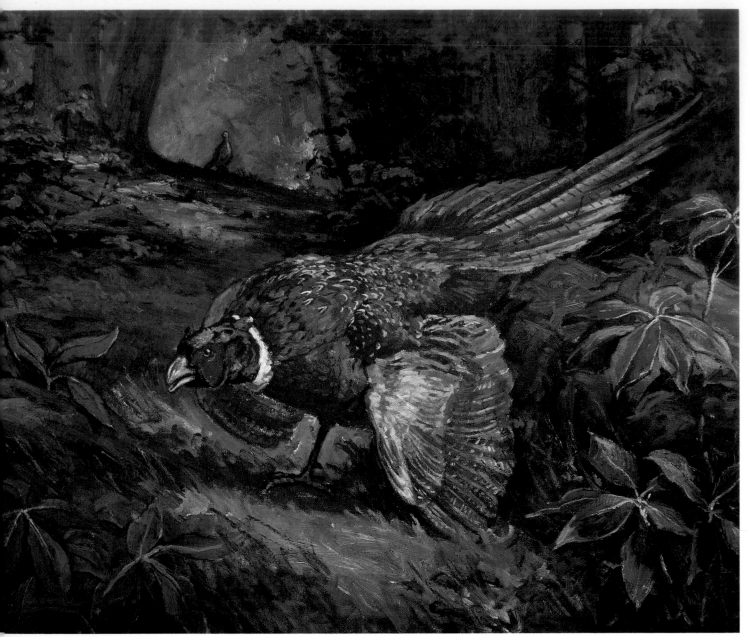

Defending His Territory, 24" × 30"

EXAMPLE THREE

In my experience as an illustrator, I have enjoyed painting a diversified array of subjects. I discovered, as you will, that the same principles of light and value apply in all painting, regardless of the subject matter.

For a while, I devoted quite a bit of time to wildlife painting. Artists cannot just imagine or make up birds such as you see here. They must have a model to paint from. A friend who does taxidermy loaned me this magnificent specimen of a pheasant, which I set up in my studio under a spotlight. Deciding what to do with the background posed a problem. Since the bird is in an aggressive posture, I assumed he was defending his territory, and decided on this theme. I took the actual scene from a path

outside my home and then I designed it so that dark values were adjacent to the lights on the bird and light passages brought out his shadow side. To do this, I painted the background with a shorter value range, keeping the lightest light and darkest dark on the center of interest. A spot of vermilion on the head of the bird became an eye-grabber. I did not try to imagine what the laurel leaves in the foreground actually looked like. I went outdoors and clipped a few branches and placed them next to the bird model. The suggestion of the hen pheasant in the background gives a broader meaning to the general theme of defending his territory.

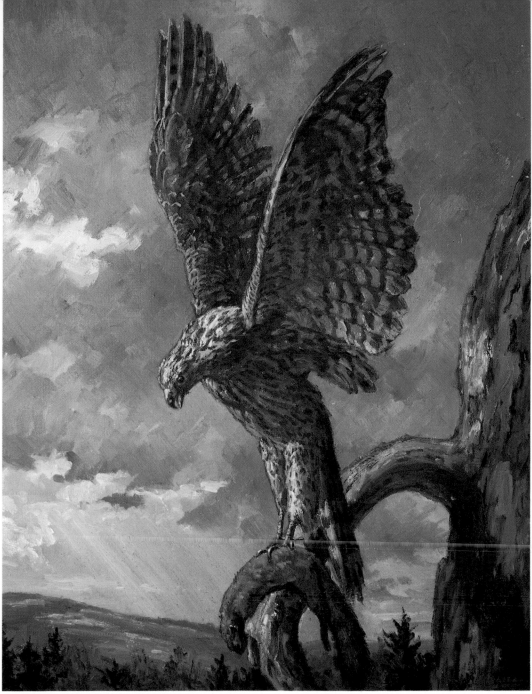

The Hunter, Home From the Hill, 30" × 24"

EXAMPLE FOUR

Here we have a similar subject, but the conceptual rendering is very different. In the painting of the pheasant, I showed you how to play lights against darks. In this painting of a hawk, the solution was to play lights and darks against a middle value.

This is a solution that I use most of the time when painting portraits. The main subject has the greatest value range—lightest lights and darkest darks both register well against a background that is a middle value. This technique lends a tremendous sense of solidity to the subject—whatever it happens to be.

Now I was committed to a middle value in the background, but I didn't want the sky to be just a plain gray. By introducing a stormy sky, I felt I was adding to the drama of the subject matter.

The only caveat here is not to get carried away with the clouds, either in detail or in value range. I chose a purplish gray to complement the warms in the hawk, and I made sure that no highlights in the clouds came anywhere near the value of the highlights on the hawk. To get an even greater sense of reality, I brought in an old log from my woodpile as a reference for the dead tree. The whole visual conception and solution to your painting must be clear in your mind *before* you start your canvas.

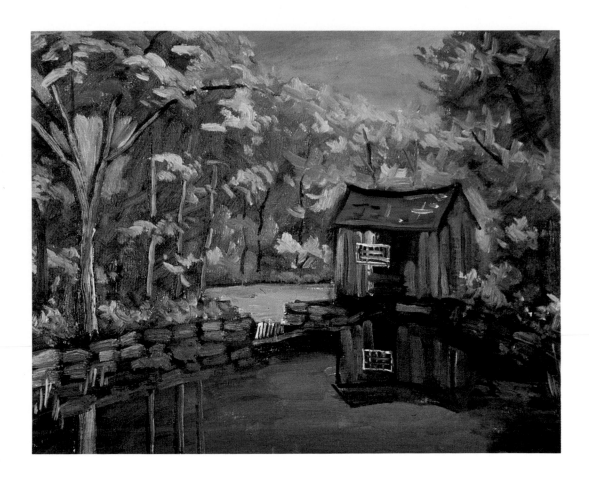

PROBLEM

This key is probably the most important single factor that will lift work out of the student level. The failure to apply this principle results in a spotty painting, as you can see above. There is no organization of the scattered lights and darks all over the painting.

The basic composition in this problem painting is not too different from the solution, but notice the following errors: The foliage greens are much the same all over. The water is painted a general blue. To some, that says "water." The reflections of trees show trunks only without showing all the leaves that also should be reflected. The problem of painting all the variations in the stonework of

the canal is poorly solved by a series of repetitious rocks all the same in size and color. The tree on the left is completely illuminated without any consideration of the fact that the leaves will cause portions of the tree to be in shadow.

There is also the absence of what we call *aerial perspective* which gives a feeling of depth that I shall discuss with you in a later key. Even though you can see tree trunks in the distance, keep them very casual and suggestive in comparison to the near trees. This will also help achieve the illusion of space on what we *know* is a flat canvas.

The Gatehouse, 24" × 30"

SOLUTION

My suggestion that you group your lights and darks together is another way of saying that some portions of your painting will be predominantly light and others predominantly dark. Study the other paintings in this book to see how there are so many variations of this principle. Try never to end up with a painting that is evenly divided between lights and darks. Have more lights in some areas, like in the distant tree mass, or more darks than lights, as in the foreground.

Study the other corrections in this painting. The foreground water is now a thoughtful rendering of the reflections. Do this right and you will have wet-looking water. Notice also the subtle introduction of an *S* curve to the

flow of water in the lower right corner that continues up and under the gatehouse.

In this section, we are concentrating on light. See how, in the upper right corner, there is a soft feeling of light rays coming from the tree mass outside the composition. The light rays are applied after the underpaint is dry with a dry-brush effect that is applied ever so softly. I use this effect quite often in my work, and quite honestly, it is seldom there as I paint. Remember my rule: Change things as long as it *could* have happened. I study light rays like these many mornings as I walk down my hill to the mailbox. Then I retrieve this knowledge and observation to use later when appropriate.

EXAMPLE ONE: PROBLEM

Many people do not know how to use the *drama of light* effectively in their paintings. Once understood and utilized, this element can improve the caliber of your work tremendously, but unfortunately it is often missing, as in the painting above. I might go so far as to say that a great deal of work has little feeling of light at all—where it comes from, what interesting patterns it creates as it flows over the terrain, and how sparkle is created by carefully designing lights against darks.

The above painting has many other obvious faults.

The lighting is flat, and as a consequence, the painting is rather ordinary. The road is too vertical and rigid, and notice how the lilac bushes behind the big tree exactly align with it. Students are often baffled by houses situated above their eye level and fail to give the perspective sufficient slant. The large tree on the right is very rigid and the ones on the left, too stylized and symmetrical. The flow of design to the hill has been leveled rather than accentuated, and we are much too conscious that the old house, even though faded, is, or was, white.

Summer Morning, 24" × 30"

SOLUTION

In this painting, the early morning light virtually sparkles as it plays on the house and splashes over the lawn and around the big tree. The most significant reason for this is that I have limited the amount of light in the painting, so what remains has greater impact against the darker passages. This painting is actually three-quarters in shadow—lights stand out against darks, not against other lights.

Let us consider what other factors make this rendition of the subject so superior to the one on the left. The slant of the hill was increased, and the big tree on the right

was curved to accentuate and coordinate this rhythmical sweep. A great problem for the student is to be specific, but not stiff, in drawing; there is a soft, flowing drawing to this whole painting. Notice how the windows, especially on the illuminated side of the house, are soft and suggested rather than hard, sharply delineated rectangles. Of course, the road is now more diagonal and has been softened with a decorative use of grass and weeds. I felt the center of interest desperately needed a little figure, and its inclusion brought the painting to a satisfactory conclusion.

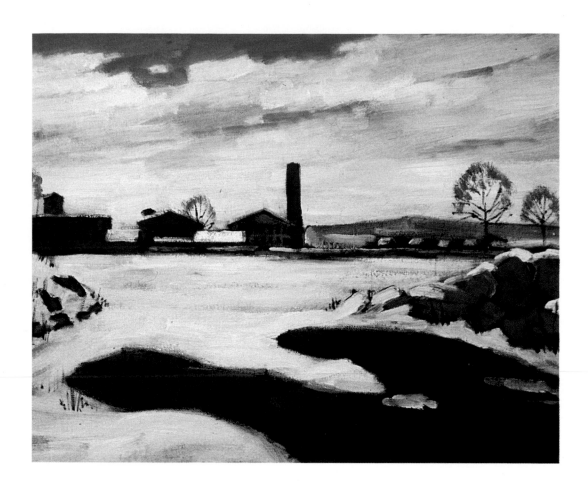

EXAMPLE TWO: PROBLEM

Limiting the amount of light is a device I use quite often in my painting, so here is an additional example, this time a snow scene—which people immediately think of as being mostly white. Light, like many other things in life, becomes more important by its scarcity: If we do not use much of it, what we do use becomes important. Because almost everything has been painted white in this painting, with no sense of the *drama of light* or its consequent shadows, we fail to have a feeling of light at all. The composition is unfortunately divided in the middle, so that we have a sky filled with clouds that rival the snow for attention. If less canvas were devoted to sky, more could have been used for the foreground open water, which, incidentally, is badly designed here. The water is so rigid it looks like a jigsaw puzzle with a piece missing.

Many times the student gives some items too much attention and others not enough. Here all the windows are put into the distant mills, but very little consideration was given to making the foreground more interesting. Paintings like this are often made from a photo or bad reproduction, and because the artist lacks firsthand communication with the subject, the picture usually leaves much to be desired. Compare this with the painting opposite, which was made on location over a period of three mornings when the average temperature was fifteen degrees. I jokingly tell my students they must learn to suffer for their art.

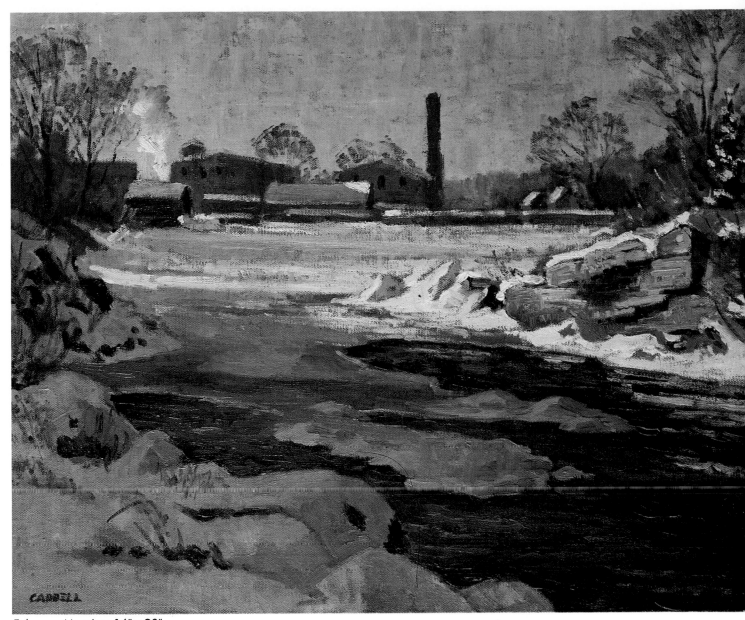

February Morning, 16" × 20"

SOLUTION

Many people think that if they don't paint snow white, it won't look right. No one would doubt the authenticity of this scene, yet less than 20 percent of it is really light. Even the sky is held down in value so we can see the boiler-room steam rising in the crisp morning air (these little details one gets only by being on location). My choice of early morning light — a time when the sun's rays just skim across the pond and climb over the snow-clad rocks, leaving most of the snow in shadow — gives us an unusual solution to the light problem. Remember that the drama of light *on* the subject is as important as the subject itself.

Notice the other improvements I made on the problem painting. Even though the foreground snow is painted in a low key, it appears luminous because it is adjacent to the dark, rich tones of the open water. An emphasis on detail in the foreground, with a more casual suggestion of it in each succeeding plane, is a marvelous help in creating distance and depth. Even though the overall detail in this painting is much less specific than in the problem one, it softly ties the entire subject together.

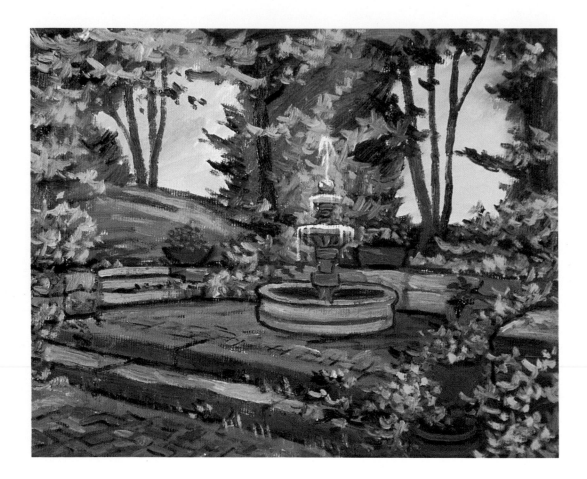

PROBLEM

The artist needs to control what people see in his painting. I have shown you previously how we use directional lines to guide the viewer's eye into the painting and blocks to stop the eye from wandering out. In this key, I want to show you how the viewer's eye goes immediately to great tonal contrasts but glides over close tonal relationships.

You should be able to see why this problem painting is not as gratifying a rendition as the one opposite. The viewer's attention is immediately drawn to the two openings in the trees, which are really of secondary importance to the patio and foundation. Because of the wrong use of values, we are creating attention where we shouldn't. Because the area behind the fountain is light, the lights of the fountain and water fail to attract attention. The

greens are too much the same all over, and the flowers are much too spotty and similar in color. The main problem is, of course, that no attention was given when designing the subject to have the light play on it in an interesting and strategic way. Too much attention was given to saying "bricks" in the lower left corner, again diverting the viewer's attention to another wrong area. The viewer's eye is jumping all over the canvas rather than zeroing in on the center of interest. The fountain is defined too much by lines rather than by the play of lights against darks that you see used so well in the solution version. The best way to observe value relationships is to squint. With a reduced aperture in the eyes, relative values become much more evident.

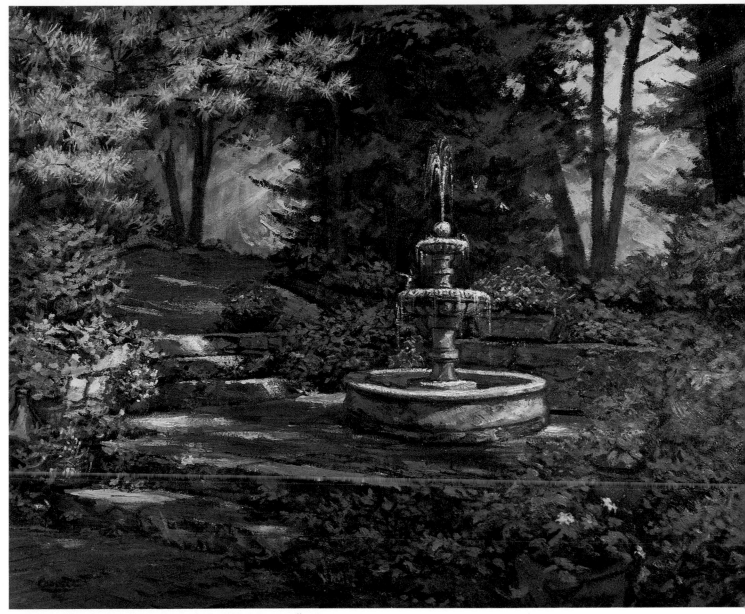

Mexico in New England—My Patio, 24″ × 30″. Private collection.

SOLUTION

The paints we use are very limited in tonal range. The range of nature is like a grand piano, and we are trying to improvise with a child's toy piano. There is a limit to how light we can make a statement. If we add too much white to a color, it becomes chalky. My answer is, "If you can't raise the bridge, lower the river." To demonstrate this point, I often tell a student, "Go out and turn the headlights on, on your auto." They don't look very bright in the daytime, but they are really just as bright as they are at night. As we lower the surrounding value, we make the lights appear to be lighter. That is the principle we use in painting. Now, if we couple great value contrasts with the center of interest, we make the viewers see what we want them to see.

Here, I wanted the viewer to see the lovely Mexican fountain outside my studio. To do this, I kept all the lights off the trees behind the fountain. Because of the distance of the atmosphere, I couldn't use as dark a dark as I would have liked adjacent to it, but I went as far as possible. I also kept competing lights subdued—the tree foliage, the sky, and in the distance over the crest of the hill.

Over the years, I have learned the advantage of not making the painting all at once, as some people advocate. The sparkling lights of the water squirting up and running off the edges of the fountain were achieved by loading a small brush with pigment and dragging it over the dry underpainting.

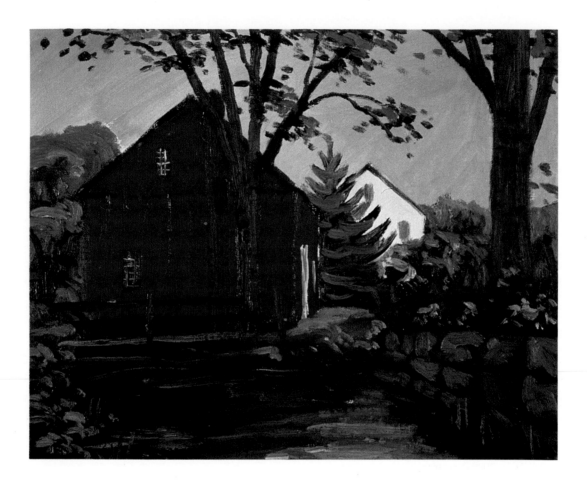

PROBLEM

I trust as you read this book and study the paintings you are realizing that the play of light on the subject is often more important than the subject itself. In all my work, it is pretty obvious where the light is coming from. There are many lighting choices outdoors because the sun is constantly moving. This is both good and bad. It gives us choices, but the light doesn't remain constant. The only lighting I do not like is what is called *flat light*, where the sun is behind the artist and it floods the whole subject, leaving little or no shadows. The opposite is called *backlight*, where the sun is shining at you, leaving many objects silhouetted against it.

Backlight is not easy to paint, but when done well, it gives a great feeling of radiance and luminosity. The main problem in painting skies, backlit ones included, is overcoming the influence of preconceived ideas. Skies are usually painted too blue with little feeling for the variations that can be made by adding other colors. In addition, it's hard to paint a backlit sky brilliant enough.

In this example, the sky is too blue and is painted flat, like a curtain hanging behind the scene. The objects have been recorded, but there is no drama of light playing on them. The water shows no effect of reflections in it, and the color blue has been resorted too. The rocks are too repetitious in size and color. The white house in the distance is painted too light.

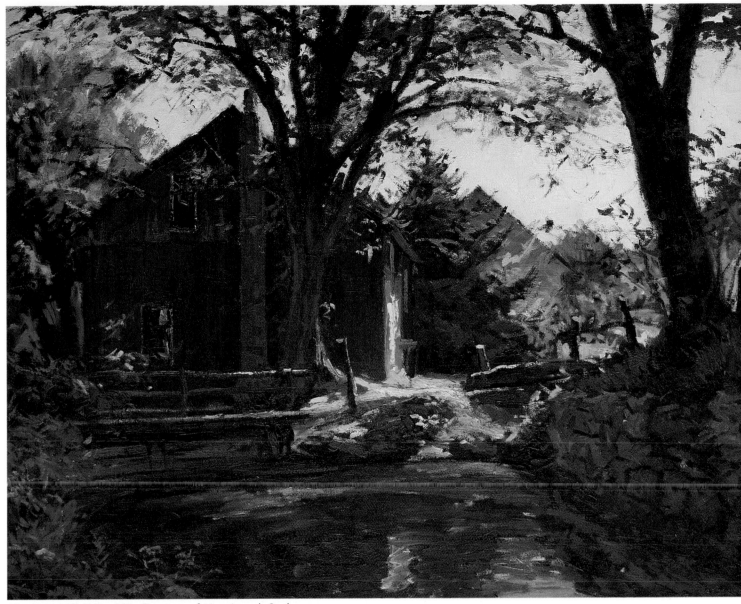

The Grist Mill, 24" × 30". Courtesy of Mrs. Joseph Scola.

SOLUTION

By going outdoors and studying nature carefully, you'll learn that skies are usually lighter when you're looking toward the sun than when you're looking away from it. Also, you'll see that a sky should *arch* in value. That is, it should be painted lighter near the horizon, and should gradually deepen in color and value as it goes higher.

To color a sky like this, it is a great advantage to mix color directly on the canvas. You can make mixtures you can't describe as a positive color where the three primary colors are always present. Here, I started at the top with a light cerulean blue and painted down. A diluted Naples yellow was then painted into the lower portion and

worked up. Now, yellow and blue make green, so it had to be neutralized by a very light alizarin crimson painted into it.

Another way to achieve a luminous effect is through contrast. By strategically placing darks, such as the large tree trunk in this instance, against the sky, and by painting the shadow side of the white house in the distance much darker than the sky, you can create the effect of a very bright, luminous sky. One of the secrets in exploring beautiful color variations is to keep your values consistent, whether it be in the darks of a tree trunk, the shadow side of a house or the bright sky.

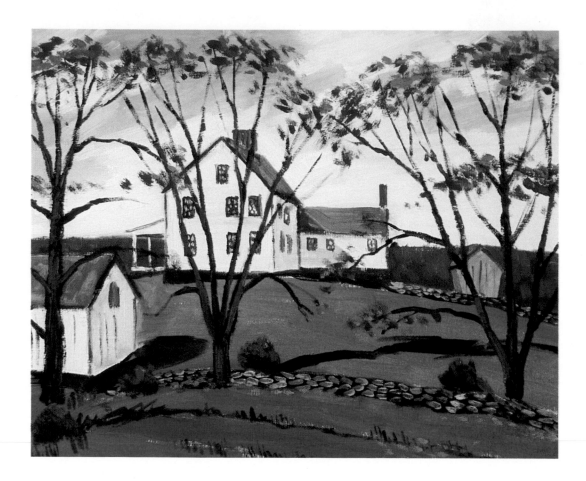

PROBLEM

Because paint has a limited range of values, we can make lights appear even lighter than they are by lowering the values adjacent to them. It is amazing what this simple formula of soft pedaling the competition accomplishes. In this demonstration, the white farmhouse is technically just as light as in the painting on the opposite page. Yet it does not look it. White does not register well against white. Remember, things do not have to be painted literally if the effect would be unfortunate.

Other mistakes shown in this example include: not enough contrast between the light and dark sides of the white buildings, not enough feeling of sunshine hitting the grass, and the greens are not being varied enough. The little stream in the foreground was painted just blue, without any reflections. The trees are poorly designed. They are all the same height and symmetrical in design. They spread out evenly, and branches tend to come off the trees at the same height on each side. There is no sensitivity to beautiful color in the bare branches and trunks, and the leaves are too spotty.

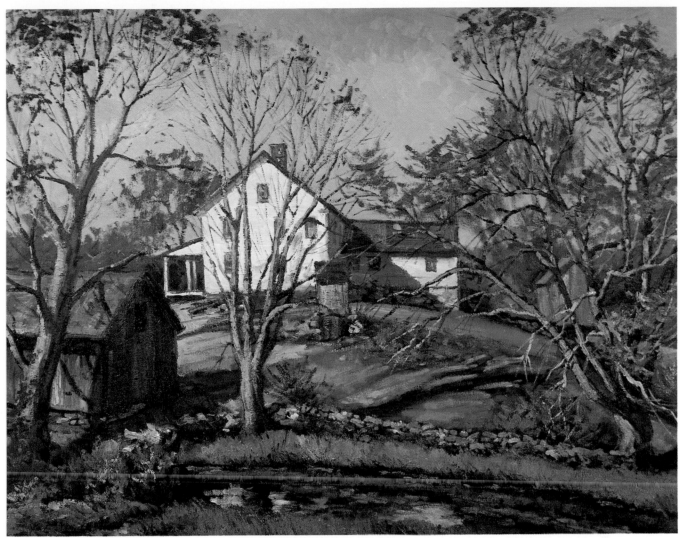

The Palmer Place, 24″ × 30″

SOLUTION

The most important interpretive change here was to paint the sky with a lower value. Also, because the lacy trees were playing over this section, I decided the sky should be quite simple, with no clouds. As I said before, the light side of the house is actually the same value in both paintings, yet see how much brighter it looks here.

To further reduce the competition, I changed the shed on the left to an old rustic one. See how the darker side of this building helps the feeling of light on the lawn? Now, just because a farmer covers his buildings with drab, gray shingles is no reason we can't introduce beautiful colors into these areas, imagining that they are old and weathered and more artistic.

The stream in the foreground does not contain much blue, yet we accept it as water. Look also at the colors in the stone wall and the more casual delineation of the rocks.

The trees in the foreground are a study in themselves. Each one has a distinctive shape and design. Because these trees had shed most of their leaves, I had the opportunity to introduce the same color around in the grass below. Study all the interesting grays in the tree trunks and branches, which I accomplished by painting warm and cool grays into each other.

I have heard for years of the theory of "underpainting thinly and overpainting heavily." You might be interested to know that I have completely ignored this principle and have found no disadvantage. By underpainting more vigorously, I find the texture of these passages, when they are set up and dry, to be such a wonderful surface to drag successive applications of additional paint over. It helps in getting softness to edges and feathering definitions in detail.

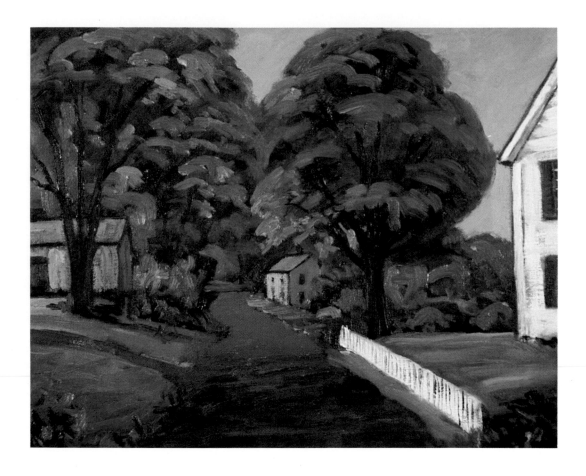

PROBLEM

A familiar phrase I often hear from students as they attempt to make a painting is, "But I don't know how to mix the colors." My standard reply is, "Color can be difficult, but even if you can't get the color, be sure to get the *value*." In the making of a picture, value is more important than color. It takes some time to realize this, but once you do, your work will greatly improve. Try making a black-and-white photo of a painting; it's a marvelous way to see if you have used values correctly. The above painting shows what it looks like if you have not. It is flat and has no snap because it has been thought out only in terms of colors. The tree masses lack form; values create form, but here the values have not been designed to play lights against darks. The trees are also uninteresting in shape, and there are no sky-holes for the birds to fly through.

The tree on the right is not placed well. It just manages to touch the house and the top of the canvas. Don't let items touch like this — either overlap the design or back them away.

The house and picket fence become much too important by being painted so white, and the student tried too hard to say "pickets." Also, the house is painted too large, making the trees look small by comparison.

The greens are too much the same, and there is no feeling of light that would enable one to see and exploit the value differences.

To help you see the lights and darks, here is a rule to remember: If sunlight is hitting an object, it should be painted lighter than you think, and if it isn't shining on an area, it is darker than you assume.

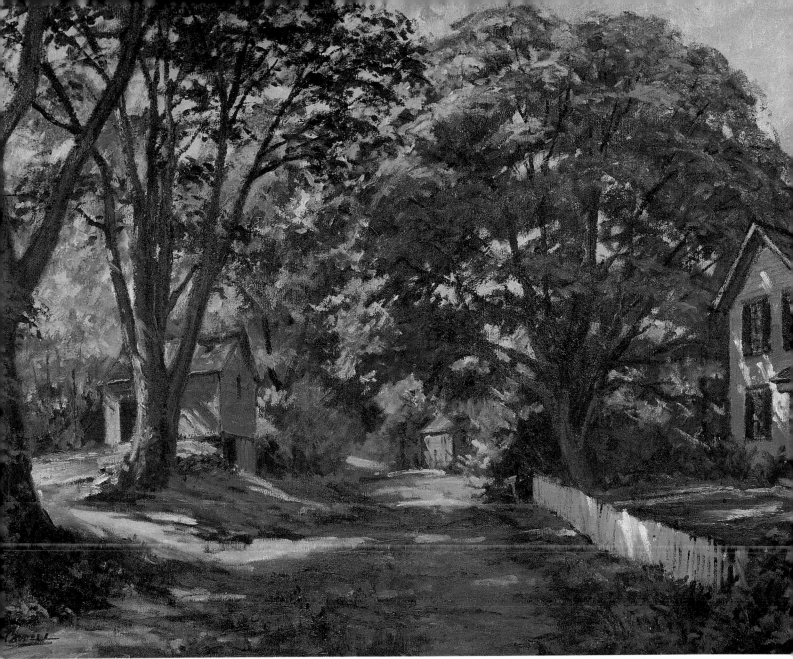

The Road by the Parsonage, 24" × 30"

SOLUTION

In this painting, we can see how the whole scene is brought to life by the careful consideration of values. Although it has beautiful colors, the point I want to make here is that the colors would be meaningless without the proper consideration of values. The gradation of values creates a sense of form not conveyed by color alone; forms register against each other without the use of outlines; and lights against darks create sparkle and sunshine. The trees are designed for variety of form, and their lights and darks play against each other in an interesting way.

The tree on the left enhances the drama of light coming in and bathing the left side of the composition. There is a diagonal thrust to the splash of light on objects that helps indicate where the light is coming from. The tree by the barn is now a silhouette against the light area behind it. On the right side of the composition, the house is now the correct proportion, making the trees appear relatively bigger. Also, I have kept the right side mostly in shadow, adding just a few splashes of sunlight on the house and fence. In doing this, the viewer's attention is not pulled from the light areas on the left.

With the road now off-center and converted to a rustic, dirt one, the entire design is less symmetrical, and each lower corner of the painting has a different solution. Notice how I let the mind of the viewer see all the pickets in the fence by suggesting just a few at the near end.

71

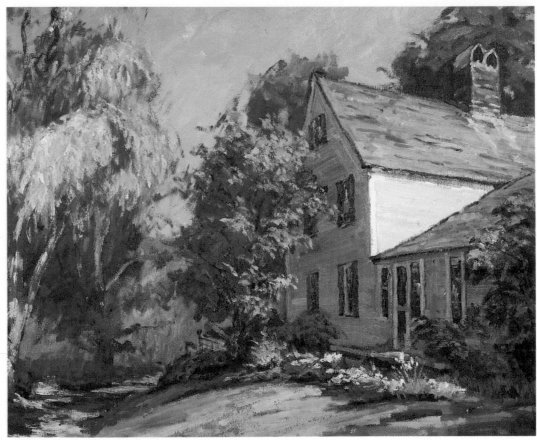

The Palmer Homestead, 1712, 24" × 30"

EXAMPLE ONE

Once again, in this key, I feel the best way to demonstrate the point is to show you two good paintings, which were made at a wonderful old farmhouse near me. Many subjects are good only under either a morning or afternoon light. This one happens to be good under both.

The first consideration to give any subject is the big pattern of lights and darks created by the play of light on it. The painting on this side was done in morning light, so most of the house was left in shadow. Remember, there are two sources of light outdoors: the sun, which is warm, and the sky, which is cool. Here we have a yellow house, which is a warm color, but it should be cool on the shadow side because that side is illuminated by the blue sky.

The secret in painting such a passage is to mix your colors on the canvas and not on the palette. I usually paint a cool color, rather purplish first, then paint the local color (yellow) into it. On the lower portion of the house, I have shown the influence of the greenish, reflected light bouncing up from the sunlit lawn.

I used the opposite approach on the small, triangular section of the house that is lit by the sun. I painted the warm yellow first and then a grayish tone into it, suggesting weathered clapboards.

The shadow side of the house gave me the wonderful dark against which to play the lights of the flowers. Notice that the trim around the door and windows is painted a cool gray—even though it's white—because it is in the shadow and illuminated by the blue sky.

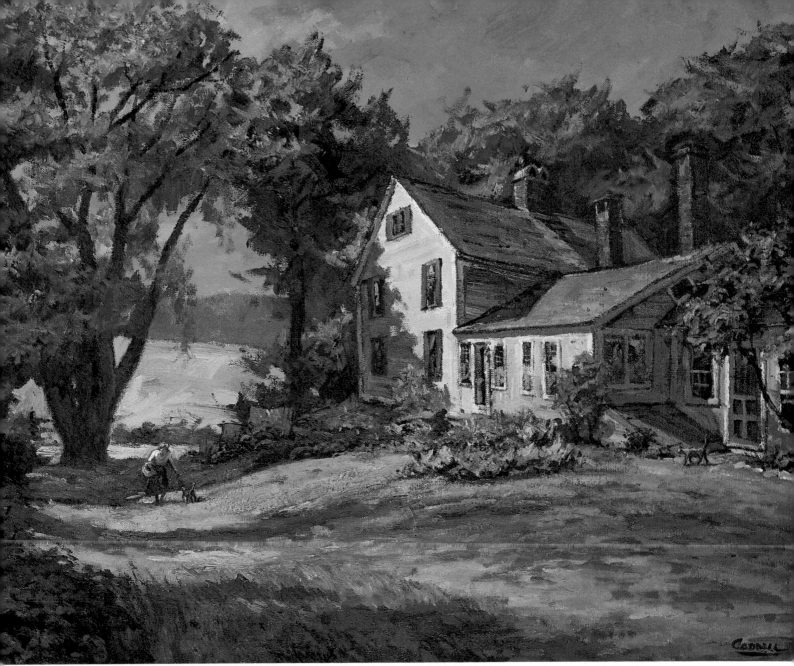

The Welcoming Committee, 24" × 30"

EXAMPLE TWO

This painting was done from practically the same spot, but with afternoon light coming in from the left. I also backed away farther to get more of the scene. By comparing these two paintings, you can see how the time of day and consequent change of lighting presents an entirely different interpretation of the same subject.

The shadow in the foreground makes the light pattern flow from the right corner over to the left corner of the canvas, where it is blocked from exiting by dark bushes. The eye then travels up the big tree and back down to the house. In this version, I played up the field in the distance, which gave me a light area against which to silhouette the big tree.

Notice the interesting cast shadows of the trees on the geometric shape of the building. There is a lot of detail in this house, but it is only softly suggested.

While I was making this painting, a friend of the woman who lives here came to visit. All farmhouses have cats around, and the ones living here proceeded to walk down to meet the new arrival. This not only presented an opportunity to add some human interest, but also suggested a title for this painting—*The Welcoming Committee*.

In both these paintings, the sky is held down a bit, so the light is more striking on the house. Also, the slight feeling of clouds in the sky echoes the color of the weeds in the lower left corner.

73

PROBLEM

Students are constantly complaining that when they take their paintings home, the lack of a feeling of sunshine in their pictures becomes evident. I can absolutely guarantee that the prime reason is that most students don't use strong enough contrast. It seems to take years to learn to give a painting the contrast necessary for it to carry well from a distance. If you're unable to judge the correct amount of contrast, you'll either paint too much or too little, although, frankly, I can't remember a student *overstating* the amount of contrast necessary.

This painting shows some typical problems. The road is at too abrupt an angle and too centered, so it appears to go uphill, and the colors used are very unpleasant. But

most important, there is a lack of contrast. The greens are very monotonous, and there is not enough contrast to say "sparkling sunshine." Also lacking here is a sense of distance and space, created by changing the color and value of the foliage.

I hope you can spot other mistakes. The tree trunks not only have bad color and value, but they are also too evenly spaced across the canvas. Try not to have nearly the same size tree on both sides of your composition, with identical areas of green running down each side of them. Have the trees lean, to give them a more interesting shape. Balance a big tree with a smaller clump of trees, as you see on the solution side.

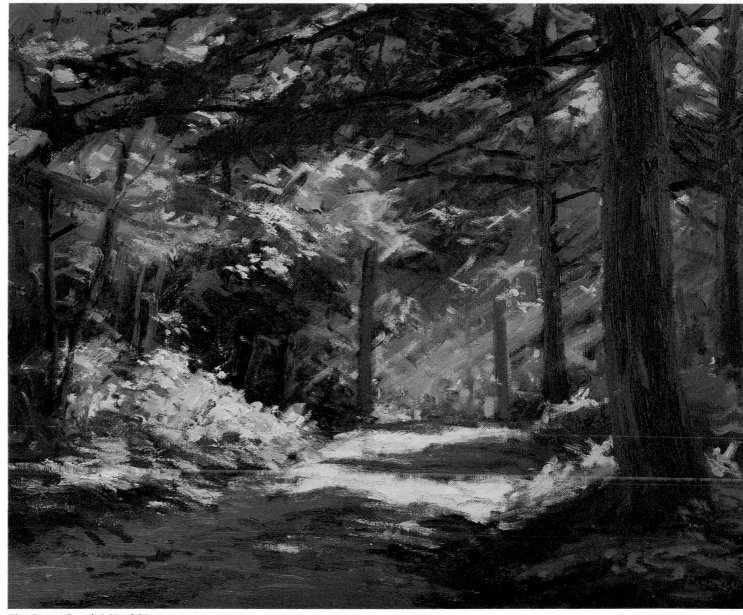

The Forest Road, 16" × 20"

SOLUTION

The longer I paint, the more subject matter I find in the ordinary. But the trick is to take the ordinary and paint it in an extraordinary way.

This is a painting of a road in our nearby state forest. As I've said, a predominantly green painting is not easy to paint. Also, the subject matter isn't at all spectacular. To come up with a good painting, you must approach it as almost a pure abstract design of pattern and color.

It really takes a terrific wallop of pigments to create a sunny effect at times, and beginners often have trouble being bold enough. Sunshine is created by strategically playing lights against darks. I can't give you any actual rules for this, other than being bolder and using more

color and contrast in the manner that you see in the paintings reproduced in this book.

This painting is another example of limiting the amount of light to make it stand out. The big tree on the right and the entire foreground is cast in shadow and silhouetted against the lights in the middle distance. The tree shadows in the road are critical in value as well as color. They must be dark enough to make the lights look bright, yet be luminous compared to the darker darks, because they receive cool top light from the sky. Once again, the soft rays of light in the distance were never actually there, but what a lovely contribution they make to the feeling of a warm summer day!

PROBLEM

In the beginning of this book, I discussed one of the most important principles I have learned in all my teaching: What you know, consciously or subconsciously, dominates your ability to see analytically. The painting above is one of the most graphic examples I can show you to demonstrate that point. In this painting (a detailed close-up of the problem), decisions are dominated by what we know. We all know that a house painted white is lighter than green grass, and that's the way it is painted here. We have to learn that the play of light can completely reverse this value relationship—as you can see on the solution side.

I cannot overemphasize the importance of this princi-ple. You see, there is no hope of painting it right if you can't first analyze what's actually taking place in the value relationships. As a doctor might say, "If you can't diag-nose, it's difficult to treat."

There are other problems in this detailed study. The shadows running across the road are a very uninteresting, "dirt" color and are of a rigid parallel design. The yellow tree on the right should have registered as a light against the dark, shadow side of the cottage. Too much attention has been given to minor details, such as the windows, and not enough to the major, more important value relation-ships.

Beachdale Lane, 24" × 30"

SOLUTION

This painting clearly demonstrates the point of this key—that is, the play of light on the grass makes it lighter than the shadow side of the white house. Here we see the point of this key—that light influences values and their relationships—clearly demonstrated.

The shadow side of the white house has to show two opposing principles. It has to be painted darker than the grass in front of it, yet it has to look light and luminous, because it is a white house. You will be faced with this dilemma many times in your work. It is solved by value relationships. By placing the darker values of the purplish trees adjacent to the house, the house becomes lighter by

contrast. I also lowered the sky a value and made it slightly purplish to enhance the warm lights of the sun hitting the yellow foliage. This instance shows another example of limiting the amount of light on the subject to make it more brilliant and effective.

Look at the amount of color variations I found in the bark of the large tree on the left, and how the play of sunlight on the tree trunk contrasts with the darker trees in the middle distance.

This was actually a dirt road. By studying it carefully, I was able to remember and reproduce it in other paintings, even when the dirt road did not exist.

PROBLEM

In this example, the student didn't see the wonderful possibilities the subject offered. This painting was done in a morning light with the sun on the left side, but the beautiful shadow patterns you see on the opposite page were completely ignored.

In any painting, you should aim for the most artistic interpretation possible of the scene, and I find shadow patterns extremely helpful. I make the most of them when they are there and even improvise them when they are not. By comparing the two paintings, you can readily see how desirable and helpful shadows can be, if handled correctly. The general composition in both instances is quite similar. The road is going right up the center, but in this problem painting, without the modifying shadow patterns and soft edges, the road is most bothersome.

The other mistakes include problems I have touched on before. The eye of the viewer is swept out of the painting by an unfortunate design. The sky adds to this problem. The sky in itself has become much too important because of the strong highlights on the cloud shapes.

The weeds in the foreground are rendered in a most unsympathetic way, harsh and spotty in design — a mistake so often found in students' work. Just about every passage in this rendition is shouting for attention.

The Patterns of September, 24" × 30"

SOLUTION

Study the above painting and you will learn a very important lesson. I have stated elsewhere that the pattern and design of lights and darks are as important as the design of the objects themselves. Two main points have been achieved by the use of shadow patterns in this painting: (1) Shadow patterns have broken up and tempered the unfortunate linear design of the road; and (2) they have given the viewer a marvelous sense of form and texture in the areas they pass over.

Let's go into detail about the first point. The horizontal pattern of the shadows over the road is now a more dominant factor than the road itself. Notice how the shadow shapes are made larger in the foreground and diminish as they go back into the picture—what a marvelous device to aid the illusion of depth.

Now let us discuss the second point. The feeling of form and contour to the land and grasses is greatly helped by the drawing line on the edges of the shadows.

In Key 39, I will talk about the principle of diminishing detail. But here, the goldenrod in the left middle distance serves as a good example. It goes from a suggestion of individual blooms to a softer suggestion in the distance. This is accomplished by dragging a brush loaded with yellow paint over previously applied (dry) green.

The tree heights on the left were raised to carry the viewer's eye up to the sky, where the cloud shape (handled subtly to prevent competition with the foreground) brings us to the right side, down the trees, and back to the beautiful tapestry of weeds, which is what I want the viewer to dwell on.

79

Place the Background in Shadow to Feature the Foreground

PROBLEM

This key expresses another way to hold down one area to emphasize another. How helpful it would have been to throw a cloud shadow over part of the landscape. Unfortunately, the sky itself draws our attention upward, when we should be dwelling on the interesting foreground.

The trees in the middle distance are painted as spots of individual color rather than as a beautiful design. They also do not register against the distant hill because they are too close in color and value.

The trees on both the left and right sides of the painting are too much the same size as objects near them. The trees on the left align with the hills beyond, and the trees on the right coincide with the height of the house. The grass in the foreground is too general and monotonous, but the small panes of glass in the old windows have been overdone. This reiterates a point I have touched on before: It's important to know what to give more attention to and what to casually suggest.

Nothing has been done to explore color possibilities in the old buildings—compare this handling to the one opposite. There is not enough value contrast in the foreground to say that the sun is bathing the scene with its warm light. More bad paintings are made of autumn than of any other season. In their effort to paint color, many students forget about values.

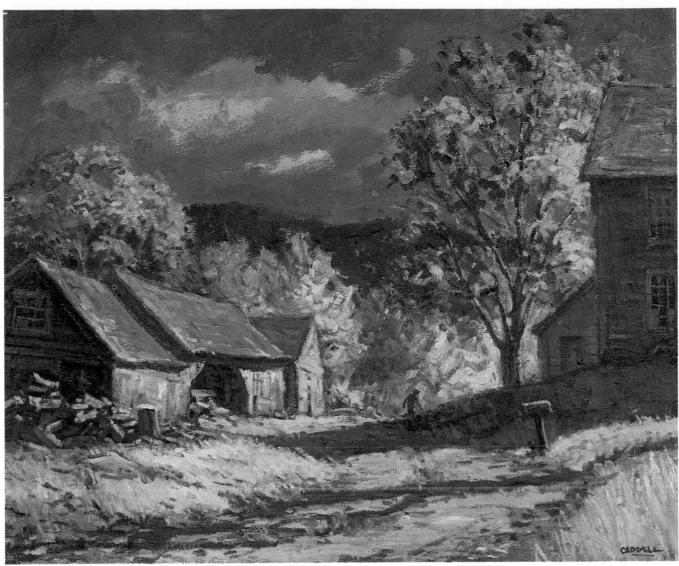

Autumn Splendor, 20" × 24"

SOLUTION

Before you begin a painting, you must decide what is the most important statement you wish to make in it. In this, it was the play of sunshine on the wonderful old farm buildings in the foreground and the adjacent trees. Remember, we bump up the areas we want the viewer to see with strong contrast and color, and reduce contrast and color on the areas of lesser importance.

This sky is purely out of my imagination; skies seldom happen exactly as you want them. It is not only more dramatic than the sky actually was, but it also gives us a darker value to contrast the trees against and a logical excuse to throw the distant hills into cloud shadow. Now the brilliant trees have greater importance because they play against darks that are basically cool.

To further improve the composition, I heightened the trees on the right and left to avoid the unfortunate alignments mentioned in the problem. I added the shadow in the foreground to complement the strong geometric patterns of the building and to make the foreground more interesting. Notice not only the addition of a figure, but also the absence of legs, which tells the viewer that the land dips down as it goes around the bend.

Notice the colors I have introduced into the old buildings. As artists, we should see and render things *artistically* and not in an ordinary way. Around old farms they do not have time to mow lawns, so the grass grows tall in places and turns a lovely warm brown. The fallen leaves that blow around in the autumn wind give a softness to the edges of the road.

PROBLEM

Much too often, the student spends time and effort recording facts and details, with no thought of the play of light and shadow on the subject. In this problem version, the general composition is not that much different from the solution. Most of the mistakes are in color and value. There is no feeling of luminosity in the sky that should be in a backlit subject like this, and no awareness of just how much light and dark contrast is necessary to say "sunshine." This is evident in the building on the left. Here, the shadows are painted as dark blobs on the old boards. And the light that does come through the leaves and hits the weathered boards is not brilliant enough, nor designed properly.

The shadow on the road is poorly designed, making an absolutely parallel shape in the lower left corner. The distant trees are the same color and value as the near ones, leaving only the size to indicate that they are in the distance.

Note the unfortunate alignment of the two buildings, and the tree masses that line up exactly behind them. When this happens in nature, you, the artist, should change it.

Sunlight on the Past, 20" × 24"

SOLUTION

I painted for years before I realized that there is a definite directional thrust to shadow patterns on buildings. The angle of the sun elongates and distorts the patterns, so they definitely point toward the source that is creating them. The far end of a shadow, if aligned with the object creating it, has to point directly to the source of light. We learn this in the studio with still-life objects, but it also applies outside to buildings and trees.

During your first day on a painting, you must be extremely sensitive to the varied light-and-shadow patterns that flow over the objects and change as the sun moves. Early in your work, you must decide on a pleasing pattern of these lights and darks, and continue to paint them, even though they constantly change. Remember that the directional thrust of the light pattern *must* point to the source of light — the sun — and must be consistent throughout the painting. As with all your painting, the light patterns must be warm in color and the shadows cool. (I'll go into the color qualities involved more in the next section.)

Another factor to be aware of is the pleasing design that the lights make as they travel from one object to another. Notice how the splash of sunlight travels across the road, goes up over the grasses, and joins the light patterns on the barn.

The silo was not actually there, but I painted it in to break the unfortunate alignment of the two roof peaks.

Detail from *Autumn Tapestry*, 24" × 30"

Section 4

Color

Color as a subject is difficult to explain because it is so elusive. To understand it, you must know it intuitively. In drawing and values, we can be more specific, but unfortunately color is different.

Students often ask if I really see all the colors that I use in a painting, claiming they cannot. I reply with the statement attributed to Whistler when someone said they did not see all the colors used in the famous *Nocturnes* — "Don't you wish you did?" I always explore every possibility for the use of lovely color, painting the subject in a more artistic and interesting way than it factually is—perhaps this can be compared to describing something in poetry rather than prose.

In most student work, you do not really feel sunshine. Shadows are cool because they are illuminated by the secondary source of light, the blue sky, but sunshine is warm in color. Let me relate a charming story told to me years ago by a wonderful, old Italian painter by the name of Nunzio Vayana. This story has helped me to remember that sunlight always should be painted warm. In his delightful Italian accent, he said, "The sun is like the woman. When the woman kiss you, she leaves the little lip rouge on your face. When the sun kisses the earth, it also leaves the lip rouge and everything is warm where she touches."

I have been greatly influenced by the impressionists, because I feel their introduction of scintillating light and color is one of the most important advancements made in painting since the Renaissance. One caution, however: Color is a marvelous thing, but it should always be accompanied by sound drawing and good values.

Mix Colors on the Canvas by Superimposing Them

In this key, I want to teach you how to study small passages of a painting to help you understand how the total effect is achieved. Above is a small section of the painting shown on the opposite page. It is reproduced approximately actual size, so you can see the brushwork.

We are now getting into a phase of painting that goes beyond the literal. My goal is to make the subject more artistic than it actually is. That is why I have little sympathy for the so-called school of *photo realism*. It makes little sense to make an absolute copy of a subject by hand.

Study the color variations shown in this small section. With poetic imagination, you can see and feel color in the weathered old boards. Over a basic cerulean blue, I painted variations of yellow and red. Quite often, when I

feel the need for a constructive drawing line, I use cadmium red light, which suggests radiant sunshine reflecting off surface edges. The hill behind the house is basically French ultramarine blue and alizarin crimson; permanent green light and raw sienna were painted into it while wet. I painted the effect of sunshine on the grass first with a layer of permanent green light, lightened with cadmium yellow pale and white, then over it I splashed cadmium yellow deep and white for the final warmth.

Most students tend to overmix their color on their palette and apply the mixture in a solid sheet of color onto the canvas, in a manner I refer to as house painting. They have to be introduced to the advantages of mixing color directly on the canvas. If you have not tried this way of

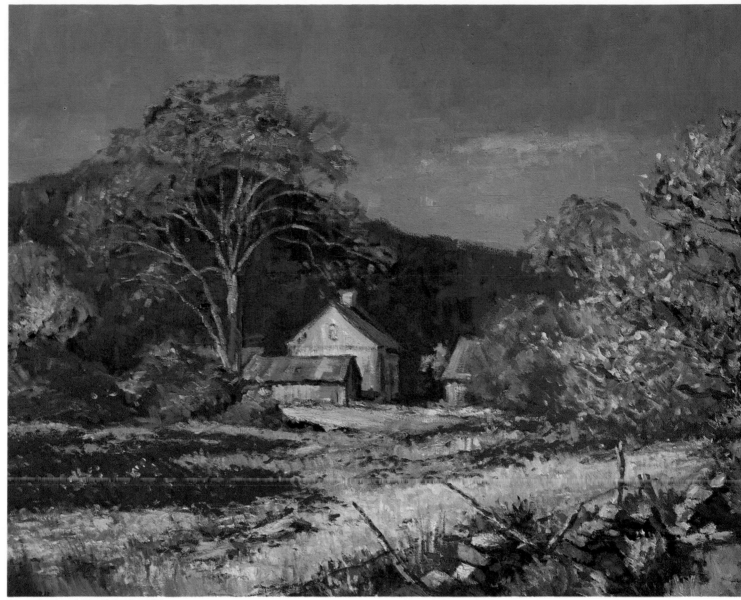

New England Motif, 24″ × 30″

working, I strongly urge you to begin experimenting.

I follow no absolute rules in mixing colors on the canvas. Sometimes I paint warms into cools, and sometimes I do just the opposite. Quite often I paint wet into wet, but other times I paint wet over dry. By experimenting yourself, you can get effects that I sometimes call "controlled happy accidents." They're far more fascinating than if the very same colors were thoroughly mixed together ahead of time on the palette and applied in a single application.

By studying my paintings throughout the book, you can see how frequently I superimpose colors and mix them together on my canvas rather than on the palette. The only caveat is that as you superimpose different colors, keep the values similar or the colors will jump out at you and won't appear to lie flat on the object.

In the painting above, I assumed that the sunlight illuminating the foreground and middle distance was coming through a break in the clouds, and that the sky was actually cloudy. I therefore had an excuse to hold the sky color down with variations of grays. The same principle was applied in playing down the distant hill, which, with full sunshine on it, would rival the foreground for importance. I just painted it as though it were covered with a cloud shadow, and in doing so, provided some lovely darks to register against the buildings in the center of interest. These are all the things you must be able to decide on and resolve before you even put a brush to canvas.

PROBLEM

A painting must "hang together." It must display an overall harmony of color even if to achieve it we have to depart from the literal colors that are there. Skies, like water, are often blue and so are thought of as always blue. In our efforts to paint an artistic interpretation, we must look for effects that are a bit different, rather than ordinary. The sky, as you can see above, is painted blue, flat and uninteresting. Because of this, we lose a great deal of the feeling of a hot autumn day, and the painting has no overall unity.

This painting obviously also suffers from poor design and the artist's lack of imagination. The composition has a symmetrical design, since the spaces and shapes on ei-

ther side of the barn are too similar. The angle it was painted from places the cupola directly at the peak of the roof and misses the sunlight playing along the side of the barn. No attempt has been made to see and use the residue of old paint that usually remains on an old building under the overhang of the roof where it is more protected from the weather. The small tree lacks a feeling of form, and the low bushes are much too uniform. The foreground field is completely lacking in character and texture, giving us another example of how the novice can fail to exploit such an opportunity.

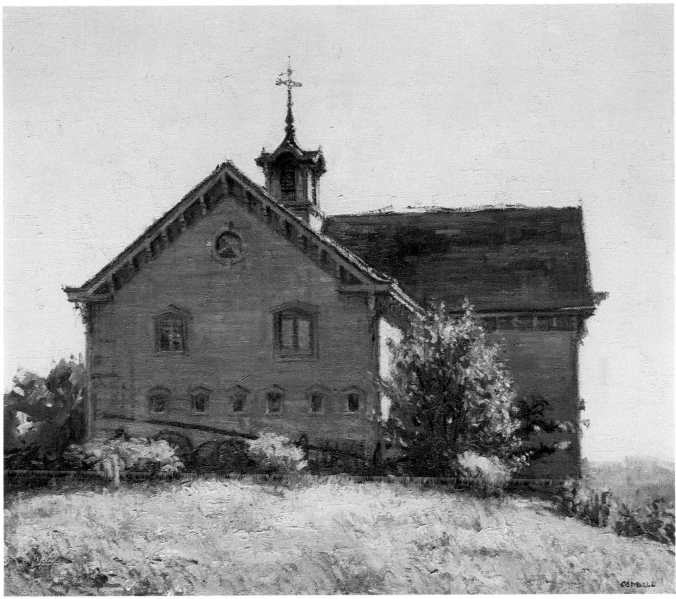

Rural Gothic, 23½" × 26". Private collection.

SOLUTION

Do you see how this rendition has a total harmony of warm tones that is achieved by painting a sky warmer than it actually was? At first, you do not even notice that the sky has been changed from the literal because the total effect is so gratifying. The luminosity of a hot, sultry Indian summer day is now very evident. This effect has been achieved by using high-keyed yellow, pink and blue in an impressionistic manner with dominant warm tones. The sky harmonizes well with the warm autumn grasses and is a pleasing complement to the cooler variations in the old, weathered boards. Notice, too, the colorful accent provided by the old, rusted lightning rod running along the ridge of the roof. The suggestion of color found in the roof shingles and on the weathered boards up under the eaves rounds out the overall tonal harmony.

Regarding the design of the composition, notice how I have made the most of the sloping hill and changed the trees on either side for a less symmetrical solution. The foreground field has been developed so the viewer feels the texture of the grass and weeds. A different point of observation throws the cupola off-center and allows us to see more of its interesting design. This vantage point also gives us a small portion of the barn bathed in sunlight. Knowing just what detail to go after, and when, is something that comes only with experience.

Perceive Colors in White

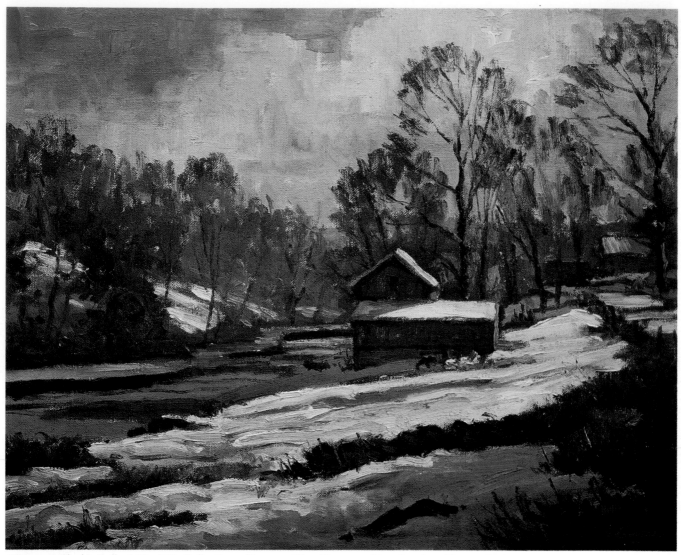

Winter at Clark's Falls, 16" × 20". Collection of Lyman Allyn Museum, New London, Connecticut.

EXAMPLE ONE

On these two pages, I hope to help you solve the problems most students have with white. This is another example of what we think we know preventing us from seeing and painting in an artistic, interpretive way. The two most common subjects that we find this particular problem with are snow and clouds. After all, snow is white; we have known this since we were children.

Many colors can be found in snow. Notice there is not one spot in the painting above that is just white. This, like all my paintings, was done on location, even though the temperature was just twenty degrees. It is the only way to get the real feel of it. Notice the blues and purples in the foreground shadows and the yellows and pinks in the highlights.

Vibrant color can also be seen in the other elements of this snow scene. The bare trees can be interpreted with lovely color and painted so that we sense a distance beyond them. The sunlight hitting the dead oak leaves is really quite brilliant because of the absence of more intense color. Even the ice has color as we note a bit of yellow ochre in the gray. The winter sun hangs low in the sky, casting long shadow patterns, which extend out over the ice.

The colors in the foreground grasses and bushes were repeated in the sky. I played the clouds down so they would not rival the importance of the snow. To make the sunlit snow appear more brilliant, I painted part of the foreground field in a cast shadow.

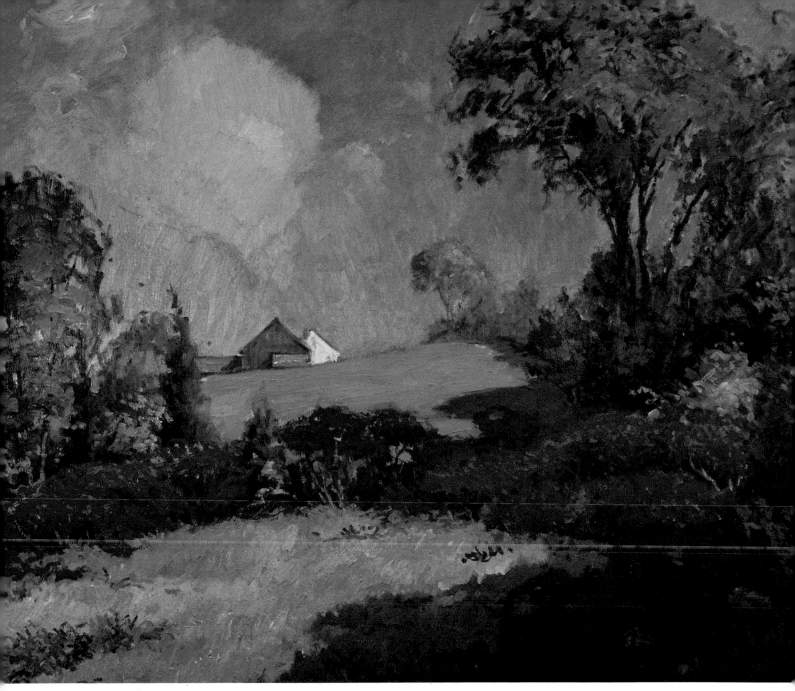

Gardener's Hill, 30" × 36"

EXAMPLE TWO

When students first start to paint clouds, they usually paint them all white. Even after they start painting parts of the clouds in shadows, they continue to paint the highlights white. In this key, I hope to break you of this habit. Here, I don't think anyone would question or doubt the impression that there are large, billowy cumulus clouds in this painting, and I have done it all without going to the high-keyed white so often employed. To point this out further, notice how I have the white farmhouse standing out unrivaled by the sky full of billowy clouds. Not only are the clouds restrained in value, but observe the lovely colors that are used in them. Notice, too, that the colors in the rest of the painting (reds, yellows and greens) are

repeated in the sky in a muted fashion. By holding the value of the white clouds down a bit, I have enhanced the feeling of the sun bathing the field of warm grass on the horizon.

Once again, I have kept a good portion of the foreground in a cast shadow. This helps the compositional design to flow from the left foreground over to the right, up the trees on the upper right side, and down to the cluster of farm buildings, the center of interest. The hill slants down to the left, but we do not go out of the composition because of the group of trees behind the red sumac bushes. The design of the tops of this group of trees leads the viewer's eye right down to the house and barns.

91

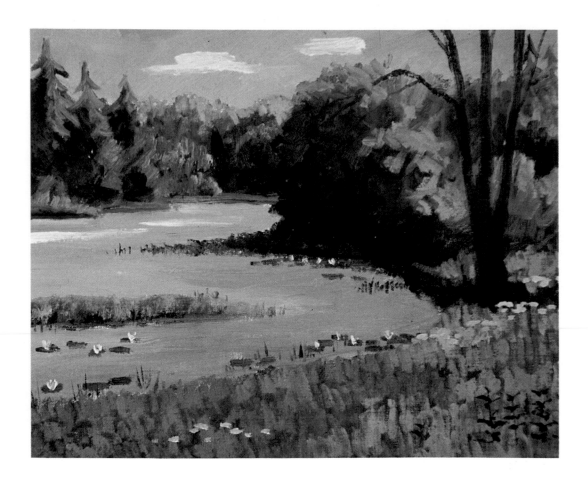

PROBLEM

Summer paintings are considered difficult because of the preponderance of greens. Generally, students do not make enough effort to seek and use warm colors whenever available. Here we have a prime example: the water. Because of various plant growth—algae, scum, pond lilies—the stream is really a beautiful tapestry of diversified colors. The average student is unable to cope with this intangible abstract design and so reverts to a simple solution, saying this is water and water is blue. It is also hard for the beginner to make the equally baffling category of weeds and grasses interesting. Like the water area, they are often left too simple, missing another opportunity of

artistic expression. The attempt here to put some suggestion of detail into the foreground is spotty and uninteresting, as is the attempt to show pond lilies in the water.

There should be lovely color in tree trunks, but they are often painted a monotonous brown. The sky here is just blue; again the artist missed an opportunity to add warm tones in the clouds. Too often, clouds are put in as white blobs because they are not thought of as having color. In the background, there is no attempt to introduce atmospheric colors and play lights against darks to advantage. The trees are unfortunately nearly all the same height.

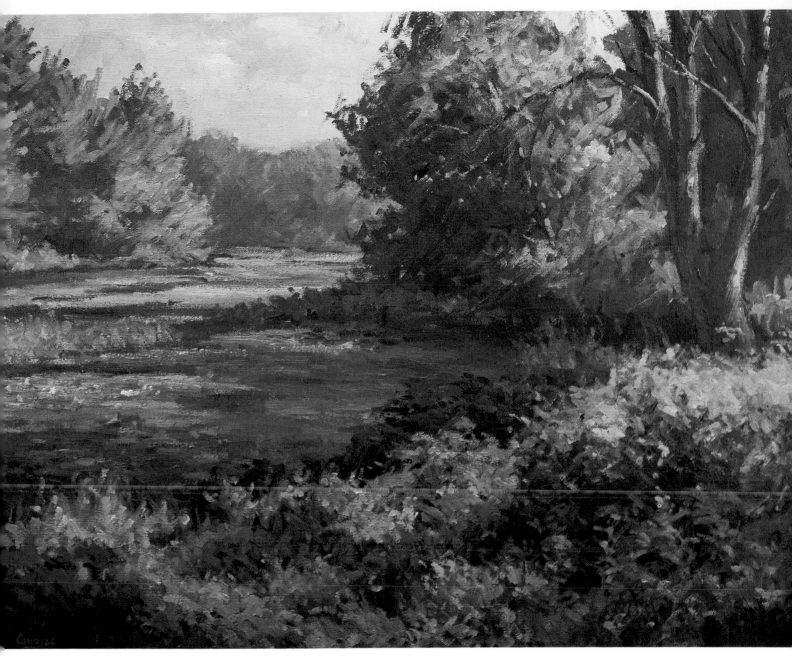

Summer Tapestry, 24″ × 30″. Private collection.

SOLUTION

The important difference here is the absolutely fascinating colors one can find in water. I actually used very little blue in this area, yet we recognize and accept it as water. The sky repeats the same warm colors and is lighter on the side that light is coming from. Darkening the foliage area behind the tree on the right enabled me to play lovely warm lights and colors on the trunk. The foreground mosaic of red weeds, called joe-pye weed, was actually out of the picture area, to my right, which I borrowed and painted into the foreground. Areas like this can be made as fascinating as a tapestry if the artist is sensitive enough to utilize the colors.

Besides taking full advantage of the colors present in the scene, I eliminated the flatness that exists in the problem painting. For example, the trees in the middle distance have been heightened so that there is a definite diminishing of size in each plane as it goes back. I have also simplified the planes in the background and played light areas against dark areas so the form explains itself better. The blue haze one finds in the early morning atmosphere is a help and should be always employed to enhance the feeling of space and distance.

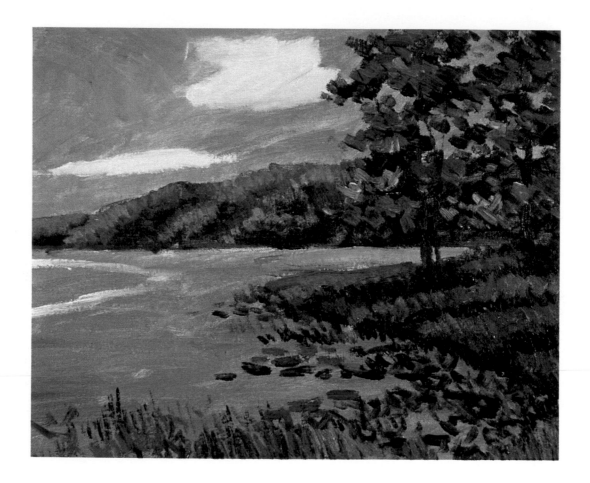

PROBLEM

One of the greatest problems in painting is how to achieve the feeling of space and air—better known as *aerial perspective*. It is only an illusion, but if handled properly, the viewer is convinced he can travel into your painting—that it is really not just a two-dimensional but a three-dimensional concept. The illusion is created with color and values; this key will deal mainly with color.

Changes in value and color are caused by atmosphere—tiny molecules of moisture and dust suspended in the air—and the farther back in a painting we go, the more atmosphere there is between the object and the viewer. Now I know that some days are crystal clear with very little atmosphere. On these days, I draw upon my memory and experience to introduce greater differences in color and values than are visible. In this painting, we

can see how the lack of difference in the greens gives us a flat picture. The greens are practically the same value and color in the distance as they are in the foreground trees, and this leaves us with only the linear perspective—the drawing—to show us that some things are farther back than others.

Let's look at several other problems in this example. All the directional lines in the composition take the viewer right out of the painting to the left. The directional thrust of the wind ripples and placement of the clouds accentuate this problem. Notice how in the solution, I introduced a peninsula of land into this section.

Finally, there was just a half-hearted attempt at painting the mass of weeds and pond lilies in the foreground.

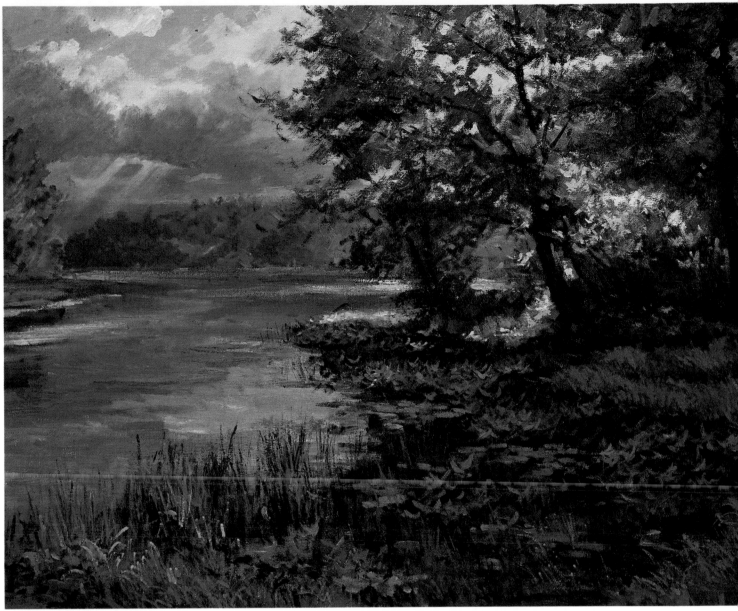

Beachdale Pond, 24" × 30"

SOLUTION

To create distance with color, you have to imagine very transparent layers of bluish gauze hanging in the air every twenty-five to fifty feet. This cuts down the intensity of both darks and lights the farther back we go, and it gives the color a bluish cast. If there is enough red present in the trees, the distance becomes purplish rather than blue.

In all paintings, there are distinctive planes: usually foreground, middle ground and distance. In each plane, I paint the shadow sections of the trees progressively lighter, with a bluish tone. This is done with the cold blue, French ultramarine, grayed with a touch of burnt sienna.

The lights also get progressively darker and less yellow.

The time of day and subsequent lighting is so important. Here, I have kept the sections illuminated by the sun to a minimum. Remember, what light and atmosphere do to a subject is as important as the subject itself.

I designed the sky to complement the directional thrust of the water and to carry the viewer *into* the painting—not out.

I enjoy painting sections such as the foreground weeds and delight in rendering the variations of colors and patterns.

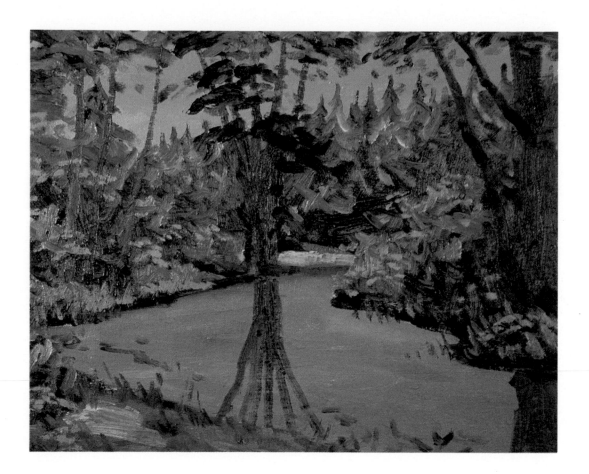

PROBLEM

One of the greatest examples of how the subconscious mind dominates our analytical perception is how we see water. If you ask the average person what color water is, he will invariably say blue, and this is the way most people paint it. For the same reason, skies are often painted an uninteresting, flat blue. Actually, water has little if any color. We think of it as blue because it often reflects a blue sky. Water acts as a mirror, and the sharpness of the reflections on it is governed by the degree of agitation.

Here you see a classic example of how many students handle water. When they begin to notice that tree trunks are reflected in the water, they put them in as rigid and sharp-edged as the tree itself. A positive reflection occurs

only in absolutely still, unmoving water, and when it does occur, I usually soften it to avoid a competing image. Of course, if the water reflects the tree trunks, it must also reflect the foliage—something the student often overlooks.

Other mistakes are the failure to introduce atmospheric color in the distant mass of trees, and too much concern that the distance is made up of many evergreen trees. Students often line them up like soldiers on parade.

But the most important deficiency here is that there is no evidence of the drama of light on the subject—where it is coming from and what it is hitting.

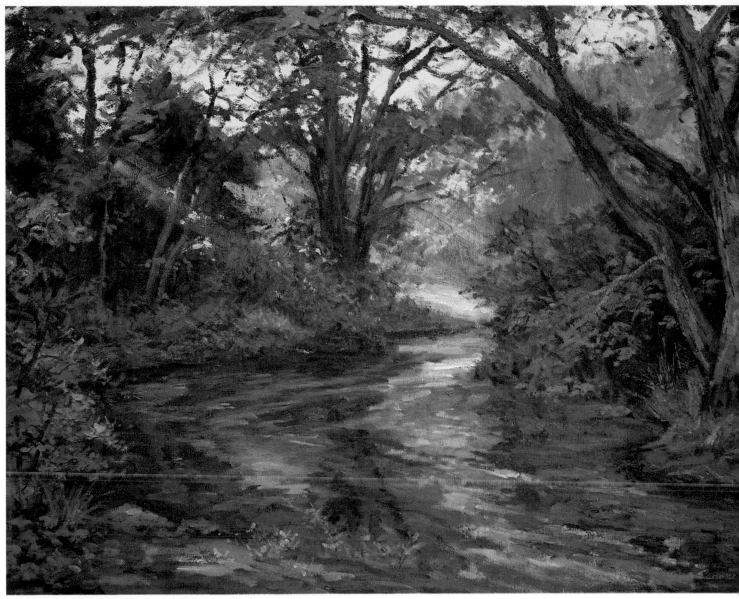

Morning Light, 24" × 30"

SOLUTION

There are absolutely beautiful patterns and colors in water if you know what to look for and how to see it. The weeds, algae, scum and plants offer wonderful chances for color variations. Believe me, it is not as difficult as you think at first. The fact that water is moving and does not remain still is a bit of a problem; but if you paint enough still lifes with colors reflecting in green bottles, you'll be able to paint water the way you see it here. Notice how everything, not just the tree trunks, is reflected in it. With careful study, you'll see a definite pattern to the flow of the stream. In painting this, I did not think of just water, but saw it as a beautiful pattern and design of various colors and values.

This subject has only two planes—a big foreground and the distance. I purposefully *overplayed* the atmospheric effect in the distance and simplified the detail.

In this painting, as in all my work, it is quite obvious where the source of light is. Notice how the sky is lighter and warmer toward the sun on the left side. Here is another example of how I introduce rays of light that were not actually there but enhance the total effect of hazy sunlight.

I hope you study the way I handle trees in *all* my paintings. Notice the interesting shapes and designs. This is why I go directly to nature to paint—how else would I be able to see all those wonderful colors in the tree trunks?

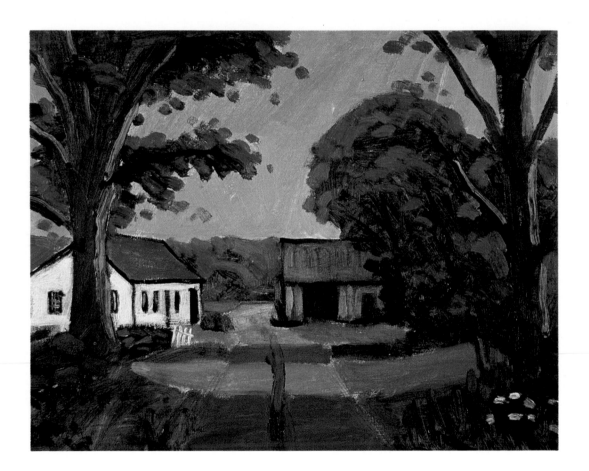

PROBLEM

There is no question that many artists' attempts to capture the feeling of sunlight leave much to be desired. They are not only timid in painting the contrast of sunshine, but they do not paint it warm enough. Everything the sun hits becomes lighter and warmer in tonality—the shadow areas that the sun does not hit are illuminated from the sky and are definitely cool. Cool areas adjacent to warm ones make the warms look even warmer. It is the basic theory of accentuation by use of complementary color.

It takes a great deal of training and feeling to see and paint beautiful colors in a plain, dirt road; most of the time they are rendered as you see here, in a rather miserable yellow-brown. Also, the road is poorly designed. It is right in the center of the composition. The edges are too hard and defined for a dirt road, and it is drawn too high in the distance.

Not only are the foreground trees badly designed, but the overall design is much too symmetrical because of the additional tree on the right. The greens in the foliage are too similar overall, and the distant trees are aligned with the tops of the house and barn.

The sky, which is too light, takes the viewer's attention away from the lower portion of the composition. The barn does not have enough light on it and is a monotonous color. There is too much of an effort to make both the cottage and the gate white.

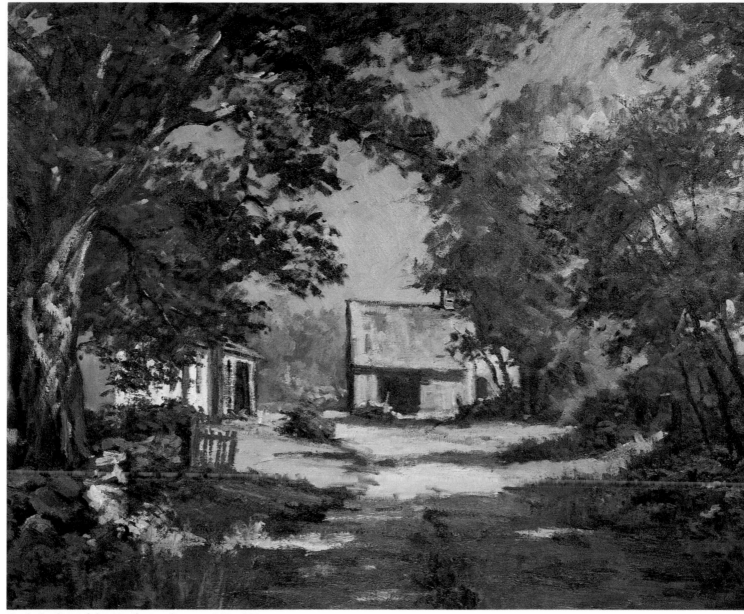

Early Settlers of the Northwest Corner, 24" × 30"

SOLUTION

I have already explained the theory behind our use of cool shadows—here you can see the results of its application. Notice first that the shadows on the road are soft and decorative. My approach is to paint them initially with cool variations of blues and purples. Then, while this is wet, I work warm earths into it, getting a delightful combination of both. As I've said before, remember to keep the values similar and do not overwork or you may destroy the feeling of variations in the colors. The shadows have to be dark enough to make the areas hit by the sun seem to sparkle, but they still have to be luminous because of the light from the sky. The few dark accents along the edge of the road help achieve this effect.

Notice also the basic coolness in the shadow portions of the stone wall, and the fact that the old white gate is darker than the grass behind it. The effect of sunlight flowing over the landscape was enhanced by painting the value of the sky just a bit darker than it actually was.

As in many of my paintings, I kept the foreground in shadow and gave much thought to depicting the patterns of light across the middle ground. A green summer painting is difficult to do, but see how I introduced warm colors wherever possible—the dried grasses, the weathered rosebush, and the chimney by the house.

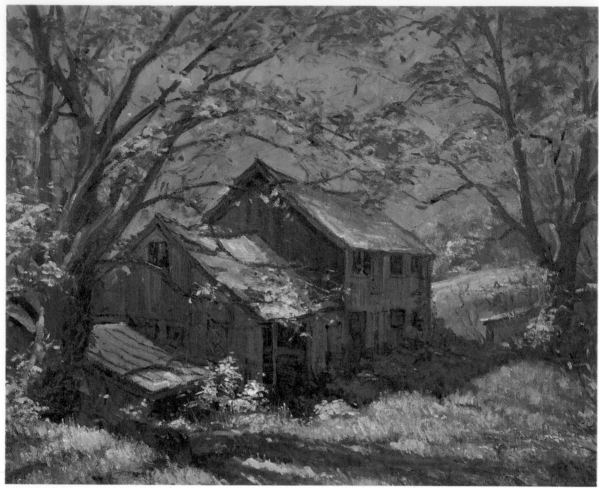

Alpha and Omega, 24″ × 30″

EXAMPLE ONE

It's easy to understand why early cultures had celebrations of spring. After the long, cold, winter months, spring is a rebirth of all the beautiful colors of the seasons ahead. The colors of spring are fresh and sparkling, and the leaves are a tender green before they're subjected to the long, hot days of summer. Like fall, spring is a rapidly changing season. The buds of one day are the small leaves of the next. Because the changes are so swift, it's better to paint a spring scene on several consecutive days, rather than to space your painting sessions farther apart.

The color of spring foliage is a light yellow-green and is different from that of any other season. One of the best ways to bring this out is by playing complementary colors (ones opposite each other on the color wheel) against each other. (A girl's red hair always looks more stunning when she is wearing a green dress.) Colors of opposite wavelengths always accentuate each other. In this painting, by lowering the value of the sky and making it slightly purple, I have made the light leaves in the foreground more dramatic.

Primavera, 24" × 30"

EXAMPLE TWO

The main subject of this spring painting is the huge maple tree, with its lacy foliage playing against a large sky area. My objective is to paint a sky that not only says "spring," but also provides a good background for the colors and values of the tree to register against. You also have to carefully study the effects of the atmosphere on the color of the trees at this time of year.

You must first decide what the sky is to accomplish here, then paint one that best serves your purpose, yet one that still looks like a sky to the viewer. In this case, I decided the sky had to be darker than the light green buds on the tree—yet not too dark. Whereas the primary color in the tree was a yellow-green, I wanted the sky to be a purplish gray—its complement—because it would accentuate the tree color better than just a plain blue. Spring is noted for its off-and-on showers, so from memory and theory, I painted a sky that felt as though the sun were

breaking through after a light shower, and that gave me the background color and value I wanted.

In the colors of the trees and hills under the influence of aerial perspective, notice the purplish base—a hangover from the bare branches of winter. As the buds come out on the trees, beautiful warm colors appear, which make you think of a softer version of the colors of autumn.

Relativity and comparison plays such an important part in painting. We have been discussing this in relation to color. This painting demonstrates its use in drawing. A tree like the one you see here can only be judged in size by comparing it to some known object. We feel that this tree is huge in contrast to the tiny figure of a man we see near it, and by the fact that it towers well over the three-story house adjacent to it. Notice how casually the house is handled. The viewer will think she sees all the detail that is only suggested.

PROBLEM

The problem in painting snow is that you may be dominated by your preconceptions of its color—especially if you don't actually go outside and see what is really going on. If you were to ask the average person to describe the color of snow, he'd probably say it is white. But a painter can't be dominated by such thinking. You must learn to see beautiful colors in everything.

In this demonstration, you see a very ordinary version of a subject that had great possibilities. The more dramatic version you see on the opposite page was begun at sunrise, and the beautiful lighting conditions did not last long. The whole area was soon generally illuminated, but I was able to continue to paint the early sunrise version from knowledge and memory.

In the problem painting above, there is too much canvas devoted to the sky to have it be just a plain blue curtain. No attempt has been made to see and paint any variations of color in the snow other than blue. The house on the right is a simple raw sienna. Note the beautiful cool variations of color introduced in the solution version. And if a tree happens to align unfortunately with a building, as shown here, move it!

The church is another example of artists being locked into preconceived ideas. A white church with white snow on the roof "has to be painted *white*." As artists, it is our task to make an artistic interpretation of the subject at hand.

Sunday Morning, 24" × 30"

SOLUTION

This painting is probably one of the best examples I can give you to show the advantage of working directly from nature, and not sitting comfortably at home, copying photos. This is the picture I was making in the photo of me painting outside that you saw at the beginning of this book. How else would I have been aware of the wonderful colors that appeared as the sun was just rising over our little rural town?

All through this book, I have been trying to make you aware that you must consider not only the subject matter, but also the most interesting light on it. Here, we see almost the entire landscape in shadow, except for a small trace of light on the red cottage. The sky is a combination of the three primary colors painted into each other while still wet. Without going to nature, how would I know that the smoke rising from the wood stoves in the cold morning air would be "warm" against the sky?

The basic principle to remember when painting snow is to see and paint as much color into it as possible and still have it accepted by the viewer as snow. When not in direct sunlight, snow is illuminated primarily from the sky above, so the colors of the sky should also be evident in snow. Although shadows on snow are basically cool, notice how many warm colors I painted into my basic blue underpainting.

Even though we are discussing color here, do not overlook the importance of *value*. What could be "whiter" than a white church with white snow covering the roof? Yet see how it becomes a dark against the luminous morning sky. If all this is painted correctly, little detail is necessary.

PROBLEM

My general observation of beginning artists is that they often revert to the ordinary solution—making things *less* interesting, while as artists, they should be making things *more* interesting.

The orderly mind makes evenly divided, symmetrical solutions to design. Here, we see the canvas divided evenly into thirds. It is a *record* of the scene, and no attempt has been made to make it into an artistic interpretation.

Notice how the snow covered, open fields in the distance are all about the same size and shape. The clouds in the sky are white puffballs, and they are all about the same size with the same space between each of them. There is a flat, overall lighting on the entire scene. Compare this to the dramatic lighting in the painting opposite.

In this version, the bare trees are all painted the same monotonous brown color, with no attempt to portray the lovely atmospheric variations that you see on the opposite page.

I am often asked questions about technique, such as how is the paint applied and how is the brush held. My general comment is that although technique is very important, the student often worries about it too soon. I often compare art to music and use it now as a comparison: If the music student has difficulty hitting the right notes and forming chords, it is foolish to worry about the finesse with which the keys are struck. Eventually it has to look as though it was fun and easy—even though you worked hard at it—and eventually it will come.

Winter's Mantle, 24" × 30"

SOLUTION

The day I painted this was an "open-and-shut" sort of day—the sun would poke through the clouds and light up different portions of the land at different times. My first decision involved how to use this effect in my painting, and just where to plan my light patterns. Most of the time that the light was on the hillside by the farm, it was also on the foreground field. I decided to keep the foreground field in shadow in order to add drama and impact to the light just beyond the farm buildings. To balance this, I chose to have the sun's rays coming down on the valley on the right of the middle distance.

In summer, the basic atmospheric color is a cold, muted blue. The atmospheric color of winter is more of a purple. Into this I paint the warm earth colors of the bare limbs and the dead leaves that cling to them through the winter. Interspersed with this is the subtle blue-green of the fir trees, a wonderful complement to the warm colors. Notice how the colors of the landscape are echoed in the clouds, which gives the painting an overall unity. Notice too, the much more interesting design of the hills in this version. I accentuated spatial planes, not only with color and values, but also with the play of sunlight over some areas and not on others. These effects are constantly changing in nature and demand great selectivity to make the most artistic composition. The cleared snow areas in shadows are bluish, and where the sunlight hits the trees, I've used warm colors. Also, the entire painting embodies a freedom of execution.

Nature has such diversified moods that, even though I have painted for years, I doubt if I could really achieve the authenticity I strive for unless I went out to study it directly. In principle, the theory of aerial perspective applies to winter, but the colors are different, a fact I would not have known had I not gone outside to study nature directly.

Detail from *September Stream*, 24" × 30". Courtesy of Mrs. Maggie McLaughlin.

Space

Space in a painting is really an illusion, but if it is depicted correctly, the viewer will be convinced it exists because he *wants* it to. The artist has various options in helping to create this illusion, and we shall go into them in detail in this section.

In painting space, the artist is actually painting air. Of course, air in itself is invisible, and what we are really dealing with are the molecules of dust and moisture in the air, which change the color and value of the objects viewed through it. You must learn to master both facets of the illusion of space—linear perspective and aerial perspective. I hope the following keys will help you to understand these important elements of painting.

An item in this category that often gets overlooked is the part the frame plays in creating a total feeling of depth and space for a painting. A frame is a transitional as well as decorative item that actually separates reality from the illusion of reality. Therefore, a painting should never be viewed or displayed without a frame.

Summer Patterns, 24″ × 30″

EXAMPLE ONE

As I mentioned earlier, space and distance in a painting are purely an illusion. If the colors and values are handled correctly, the viewer is convinced that he can see great distances. This is what we refer to as *aerial perspective,* or the diminution of values on each receding plane. The farther back the area we are viewing, the more molecules of moisture and dust are between it and us, so consequently the values and colors change. On some days we can see the effect of haze much more than on others. In the above painting, the tree on the left is painted the actual color of the foliage. It is close, and there is a minimum amount of air between it and us to change the color and value.

A painting usually includes three primary planes, namely, foreground, middle ground and distance. Notice how in each plane the value range gets shorter. The darks are not as dark and the lights are not as light. To create

a feeling of sunshine, I lighten the darks more than I darken the lights.

I carefully planned the composition to play lights against darks, and I take every opportunity to diminish sizes as planes go back. The trees in the foreground go right out of the canvas, as you will notice in so many of my compositions.

A common mistake is to paint the tree trunks in the distance too dark. The trunks are usually very close in value to the shadow value of the foliage of the tree. Notice how this is handled in the middle ground here. The trunks are defined by painting the more distant area around them.

Just remember, no matter how dark they look to you, they cannot be painted as dark as the trunks and branches in the foreground.

Farm at Escoheag, 24" × 30". Courtesy of Dr. and Mrs. Christopher C. Glenney.

EXAMPLE TWO

This painting is a classic example of both the principles of this key. You can see the definite progression of values — especially in the shadow portions of the foliage. Also, the buildings and trees get decidedly smaller the farther back they go. It isn't possible to do this in every instance, as there are exceptions, but I do it at every opportunity because it is so helpful in creating depth in a painting.

I spent a great deal of time finding beautiful variations of colors in the old buildings. How interesting the geometric patterns of light and dark are in contrast to the softer designs of the trees! Notice the tapestry of colors I found in the grasses and weeds of this farmyard, including the dried brown grass — welcome warm tones in a summer painting.

The farm wagon was not actually there. I added it later, believing that it helped the overall composition and lent itself to the antiquity of the scene.

With so much space devoted to the sky, I felt that it should not be just a plain blue. However, if the landscape is very interesting, be careful not to make the sky too complex. Paint it in an interesting way, yet keep it subdued and in its proper relationship to the rest of the composition.

I hope you are beginning to realize all the planning and thinking that goes into making a landscape painting. Again, I stress that the fundamentals of learning how to analyze and paint the various colors and values should be learned beforehand. That is why it is so important to paint still lifes in the studio under more controlled and comfortable conditions. It's a lot easier to cope with what to do if you know how to do it.

Diminish the Size of Trees as They Recede

Lacy Elms, 24″ × 30″

EXAMPLE ONE

I believe the most important achievement in painting is to convince the viewers that they are looking at space and air — not a flat surface. Even though I have touched on this before, I want to bring to your attention how important the designing of trees can be in achieving this goal. We all know that as things get farther away from you, they appear smaller. I use this simple fact so often in my handling of trees. Look through the entire book and notice just how often I use this important factor.

Whenever possible, I make the closest tree the largest, and the tree itself goes well up and out of the canvas. The trees then get progressively smaller as they go farther back in the overall scene.

Because I wanted to emphasize the impressionistic feeling of the leaves, I kept the sky behind them simple in design and a step down in value. I also kept the handling soft to emphasize the spottiness of the leaves. Because of the minimal leaves on the trees, the shadows on the road are linear from the trunks and branches.

For an autumn scene, this is not too colorful; that is why the poison ivy vine climbing the tree trunk on the right seems so startling.

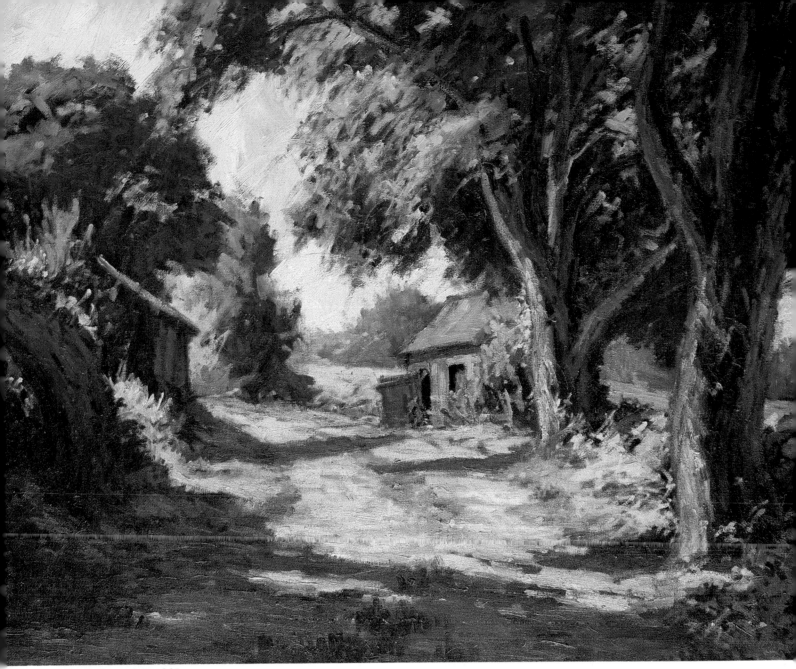

Shady Lane, 24" × 30"

EXAMPLE TWO

Here is another classic example of the subject of this key. Notice the aerial perspective as well as the linear perspective I have used here. This is accomplished by reducing the value range on both ends. The darks of the foliage get lighter in each step back, and the lights get progressively darker.

There is a wonderful feeling of sunshine in this painting because of the strong contrast in the foreground. The foreground shadow on the road is cool, and it makes the sunlit portion look warm by contrast.

Notice the large tree trunk on the right. We know from studying still-life paintings that there are only four basic shapes in the world: the cube, the sphere, the cone and the cylinder. The tree trunk is just a wonderfully distorted cylinder and must be painted that way. There is the

area hit by light, and there is the shadow area, but don't forget the reflected lights in the shadow areas—they are what help the trunks and branches look solid and round.

The barns contribute some strong geometric shapes in contrast to the flowing lines of the trees. I introduced the little figure with a red shirt, as a spot of interest, against the shadow side of the barn door.

There are many little things done in a painting that arc so subtle they often go unnoticed—except by the person who can study and really read a painting. In the upper left corner, the light foliage of the big tree in the middle ground overlapping the dark section of the tree farther back is a useful device in creating a sense of space and distance. Little passages like this make one object definitely closer than another.

111

Create Depth by Strengthening Foreground Detail

PROBLEM

In this key, I want to teach you the importance of handling detail properly. Generally speaking, I use a greater amount of detail in the foreground and gradually lose it as I work back through the middle ground and distance. You might think of it as if you were nearsighted, and to you, the foreground appeared sharp and detailed but the farther back you looked, the more out of focus everything became. Here we can see that this concept has not been used, and the painting has suffered because of it.

This demonstration displays several other mistakes. Too much of the canvas is devoted to the sky and the white clouds. The greens of the foliage are too similar in color and value. The clumps of grasses are all the same size, and the pond lilies are uninterestingly spotty.

Let's look at the section in the center, where the water goes round the bend. When water goes back in a painting, students tend to make it go up too high, as they do with roads. Notice how the water goes up to the level of the brown bank on the right. The angle of the shoreline is much too severe. As a result, the water looks as though it goes uphill. Keep the shoreline more horizontal, as you see in the solution. Let the *S* shape flow out of the composition and back into the foreground.

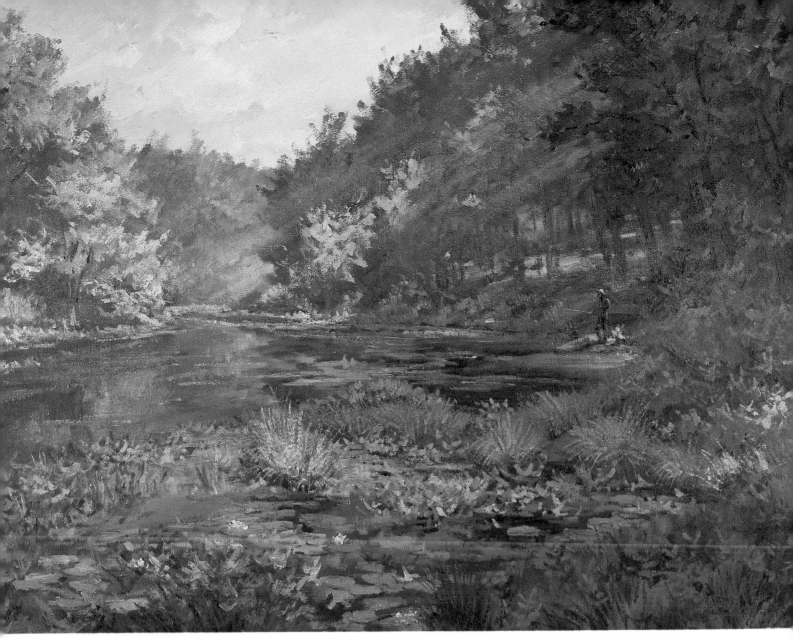

A Quiet Time, 24" × 30"

SOLUTION

Here we see how the same picture is much improved by keeping the greatest detail in the foreground and conversely simplifying the distance. In the middle distance, there is still detail, but not quite as much as in the foreground. When we reach the background, we simplify. Notice how the trees in the middle ground register against the background clearly—as darks and lights, they register well against the soft, middle tones of the distance. To further enhance the feeling of depth, the tree masses get progressively smaller, along with a reduction in the value scale.

This is a very important key to remember. Unless there is some aesthetic reason not to, concentrate on developing much more detail in the foreground of your painting and on gradually losing it as you go back through each successive plane. When the distance has been simplified and the foreground strengthened, you have a power-

ful tool to create the illusion of distance and space.

Notice the limited amount of light in this composition. The right side is mostly in shadow with just a few carefully designed lights sneaking through in a decorative manner. On the left side, there are more lights than darks, a principle I explained in an earlier key. The soft rays are a result of artistic imagination; they demonstrate just where the light is coming from.

The bare ground under the pine trees on the right bank gives warmth in an otherwise green summer painting. The sunlight splashing on the fallen pine needles provided a change in design and pattern.

The figure was included to add interest. There were fishermen there off and on while I was painting, and I created a synthesized version of them. Note the fleck of light on the back of his red shirt.

113

PROBLEM

When faced with the problem of a body of water in the distance—be it a cove, as in the painting above, or a lake—many students make the same mistake. In their effort to make the water recede, they keep making it go higher on the canvas. If there are no buildings with perspective lines in the painting, this approach merely makes the body of water grow huge. It seems difficult to realize that the viewer is looking *across* the water, not down on it. If there are buildings present that show us where the eye level is, then the water looks as though it goes uphill at an angle, which, of course, is impossible. We all know that water cannot flow higher than the eye-level perspective line. Here again is a case in which what the student knows dominates his perception; he knew there was a large cove out beyond the shack and pier.

Other problems include the sky, which was made much too important by the spotty, white clouds. The greens are all the same, and no effort was made to include aerial perspective. With the sky and the water, there is too much blue in the painting. See the improvement made by waiting until later in the afternoon, when the colors were much more interesting and artistic.

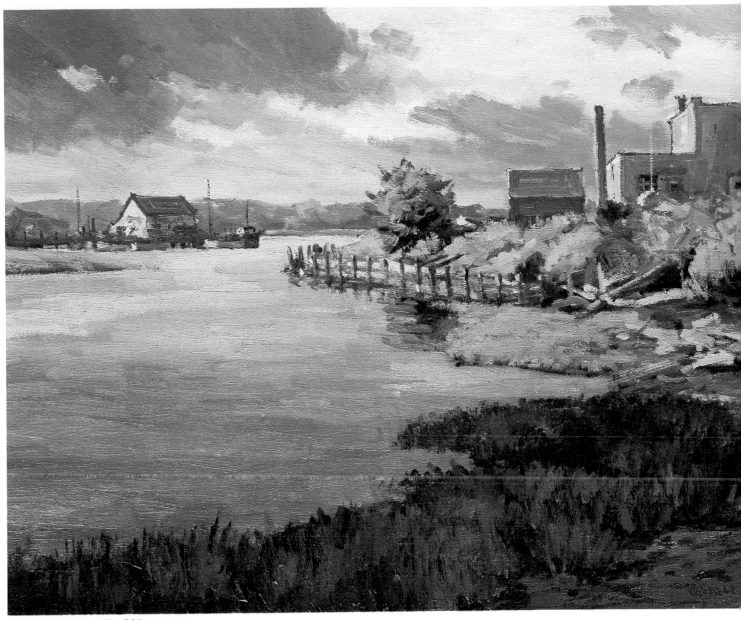

Wickford Cove, 16" × 20"

SOLUTION

I think this painting shows you the answer. Water just cannot go above eye level. We know that there is a large cove out beyond the buildings, but we have to remember we are looking at it from a low vantage point, and that it appears as merely a low, flat line under these circumstances.

In this composition, the eye level was raised, giving us more foreground and less sky. The foreground grass is designed in a much more interesting way—it now enhances the directional thrust of the foreground water from left to right. The early evening sky went well with the foreground yet did not compete with it. Notice how the clouds are designed to form a complementary opposing angle with the design of the water.

The flotsam and jetsam that collect at the waterfront can become lovely passages of color and design. You do not have to show exactly what it is. A few judicious brushstrokes of color are sufficient; the viewer's eye will do the rest.

This painting is very colorful because the source of light was the descending sun, but even so, the values must be right. It's also another example of how to create a greater sense of illumination in the middle ground center of interest, by painting the foreground in shadow. In this case, there could be no big trees off to the left to cause a shadow, so I created cloud shadows to sweep across the land—even if only momentarily.

Detail from *Meadow Patterns*, 24" × 30"

Skies

When it comes to skies, there is no doubt that here nature puts on her greatest display of virtuosity. There seems to be no limit to their moods and variations. Actually some artists, such as Eric Sloane, have specialized in painting what they call *skyscapes*, and have shown us the tremendous possibilities that exist in this single field.

This section is a good place to mention a concept recognized by all artists: When compared to the *real thing*, a painting always looks inadequate. Nature, with its range of tonal variations, is like a maestro playing on the keyboard of a grand piano, while the artist, with his limited palette of paints, is like a child on a toy piano, trying to imitate the maestro's performance. Only when you get the canvas home, away from the reality of your subject, can you begin to recognize if your humble efforts have been successful.

In this section, we are dealing with two primary approaches to painting the sky: Either the sky is a dominant factor and the main theme of the painting or it plays a subordinate and complementary role to the landscape. I can honestly say that the ideal solution to a sky does not always come along while you are painting a landscape. What you actually have to do is to figure a theoretical solution in terms of color, pattern and value to your sky and then design the composition of it accordingly. This is why you must *know* skies and be able to fabricate one just as though it were actually there. To facilitate such a familiarity with skies, I strongly advise many hours of studying and sketching them. I have found pastels excellent for this purpose because you can work rather rapidly with the medium.

PROBLEM

The problem here is to design a sky to complement or enhance your landscape. When you're painting a still life in the studio and you want a certain background, you hang up the appropriate cloth and paint it quite literally. But outdoors, Mother Nature is not as cooperative. So your ability, knowledge and tasteful selection have to fill in the gap, because the sky in a painting must serve a definite purpose. Painting skies is one of the hardest things to conquer in landscape painting. It's difficult enough to paint what's *there*; it's practically impossible to paint what's *not there*. Even if the ideal sky is there, it isn't for long. A critical decision in all paintings, but particularly in this one, is the time of day selected to depict the scene, and the choice of the ever-important play of light over the subject.

In this example, too much canvas has been devoted to the sky, and it fights the landscape for attention. One has to choose which area of the painting to have the viewer concentrate on, and subordinate the other areas. Here, everything is shouting for attention. Each area is saying "Look at me, I'm important." As a consequence, the painting has become much too busy overall.

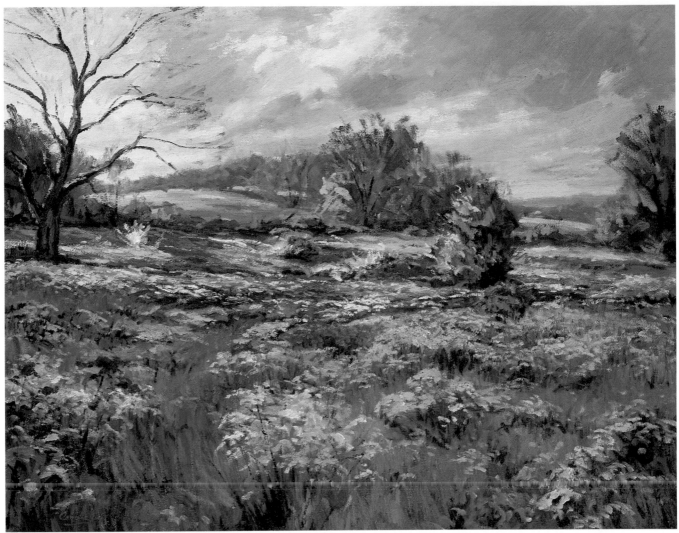

Late Summer, Late Afternoon, 24" × 30"

SOLUTION

To paint a sky such as this one, first analyze what is needed. When this much canvas is devoted to the sky, you must put some interesting pattern into it without upstaging the landscape itself. Also, the colors you use must complement and harmonize with the landscape. To depict the time of late afternoon that I chose, I designed the sky so that the greatest amount of light areas is on the side that the sun is coming from. I also made the dominant flow of the cloud masses complement the angle of the hills. Having all this in my mind *before* I started, I painted the sky. Although I'm grateful for any help I get from nature, most of the time you have to paint it from memory and theory, as I did here. This particular sky was painted in about a half-an-hour—but of course, that was after thirty-five years of experience.

Study the various techniques in these good examples. Technique is important—after you have learned the basics of drawing and color mixing.

The sky is handled softly, wet into wet. The upright strokes of the grass in the foreground make you feel you can look down into it. Warm colors of dried grasses are interspersed softly into the greens. When the grass area had set up a bit, I carefully painted the patterns and colors of the wildflowers. As Sargent once said, "I work so hard, so that it doesn't look like work."

The foreground shows another example of painting a big, abstract design. First of all, I wanted the center of interest to be in the middle ground, so I cast the foreground into cloud shadow. This gave the wild asters a coolness in color, so they are tied in with the sky color. Rather than painting individual flowers as in the problem painting, I depicted them in carefully designed groups, which aid the composition as a whole. The flowers are larger in the immediate foreground and merge into groups as they recede. The big bare tree on the left was out of the picture composition, but I brought it in to stop the viewer's eye from leaving the picture.

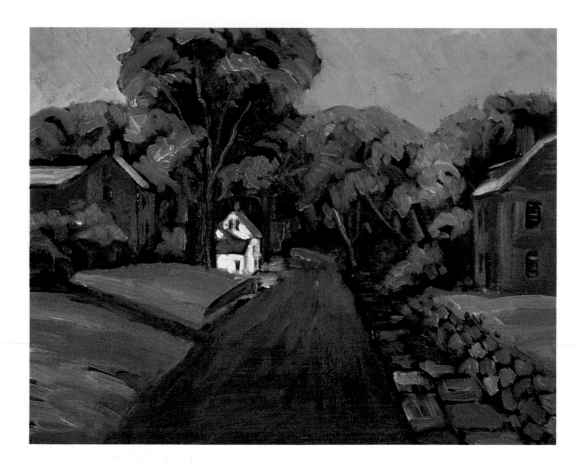

PROBLEM

To achieve a feeling of light, you have to use every means at your disposal. One simple device is adjusting the values in your sky. The next time you are outdoors painting, notice that the sky is usually lighter closer to the sun and grows increasingly darker as you look away from the sun. Because of clouds or other atmospheric conditions, this principle may not always appear to be true, but most of the time it is. What a simple device to help the feeling of light in your painting! Look at the paintings in this book and see how often I have used this theory to advantage. See how much less effective the monochrome sky is in the problem painting above.

Other typical mistakes include the design of the road. It sits right in the center of the picture, and nothing has been done to make it lie flat or modify the directional thrust. In handling things like the flagstone walk or the stone wall, the student is usually too conscious that it is made up of large squarish stones and does not really *see* them and design them carefully so they lie flat.

When painting buildings, choose a time of day that the light plays on one side and not on another. This is such a wonderful way to make objects like this look *solid*. Be aware of the only exception: When painting backlight, sometimes the light hits only on the rooftops.

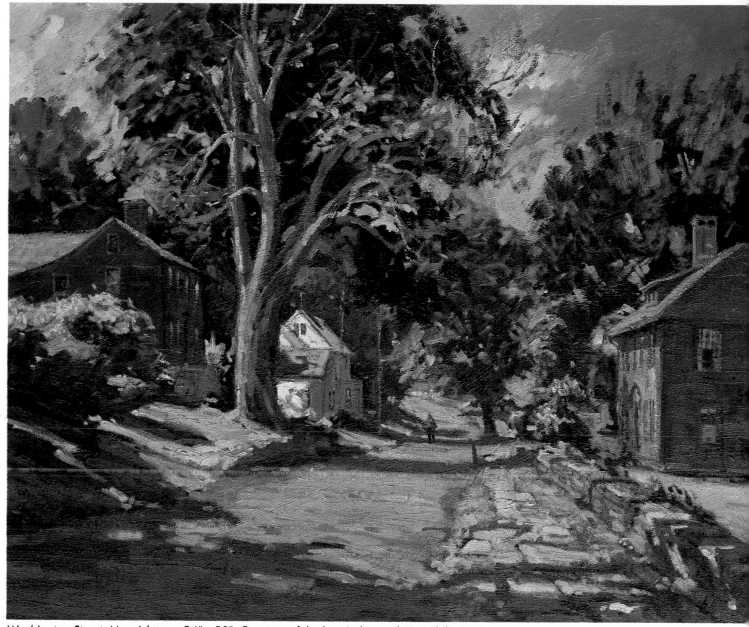

Washington Street, Norwichtown, 24" × 30". Courtesy of the late Judge and Mrs. Philip M. Dwyer.

SOLUTION

In all my paintings, I am very conscious of the drama of light coming from a definite direction and playing over the forms in an interesting and artistic manner. To show the viewer *where* the light is coming from, I quite often paint the sky lighter on the side closest to the sun. See how the sky in the upper left, above, is quite a bit lighter than in the upper right. I do not prescribe this in every case, but I do use it quite often.

Always choose a time of day when the light creates not only form but also beautiful patterns. The foreground shadow pattern—which came entirely out of my imagination—is designed not only to soften the thrust of the road, but to convey a feeling of form to the terrain. Notice how

the shadow pattern flows down the bank on the left, splashes decoratively across the road, and climbs up and over the stone wall on the right.

This scene is one of the few instances in which I have not converted the road into a dirt one. This is a well-known street in nearby Norwich, Connecticut, and I did not feel that I should. In fact, I even included the telephone poles, but notice how casually I suggested them.

I urge you to study the handling of trees in all the sections of this book. Look at the construction of the trunk and limbs of the one near the center, and see how the big shapes get progressively smaller as they go back.

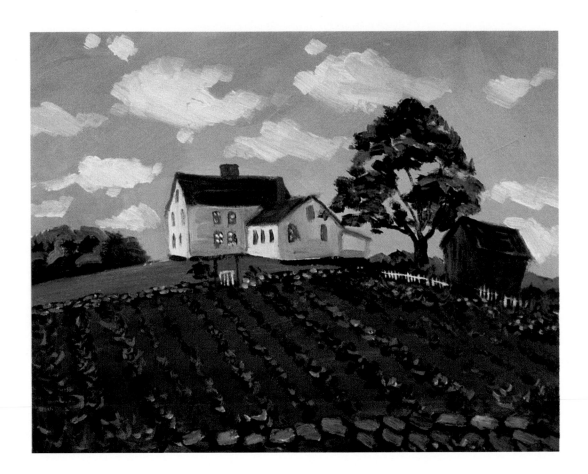

PROBLEM

In this example, the subject is designed much too small, and too much area has been devoted to the sky. When a building is above eye level, over half of my students will draw it wrong, as I'm showing you here.

I have previously touched on the principle of deciding *what* you are saying in your painting, and subordinating other passages to this main theme. Most of the time, in my work, the sky plays an interesting, yet subordinate, part in the overall orchestration.

At the beginning of this book, I told you there are only three elements involved in making a painting: line, value and color. You must apply this thinking to every section of your painting, and skies are no exception. Before you put brush to canvas, you must decide on the shapes (drawing), the value and the best color. In this example, none of these elements was considered. The sky is too busy, too light (it competes with the light on the house), and the color is too ordinary. I want you to spend time studying the two examples so you'll be able to eliminate these problems from your own work.

In all my years of painting rural New England, this was the first time I actually painted a garden. When my students were at this location, most of them painted it as you see here. They were too concerned with the fact that they saw individual plants and they were not able to see the beautiful overall pattern that you see on the opposite page.

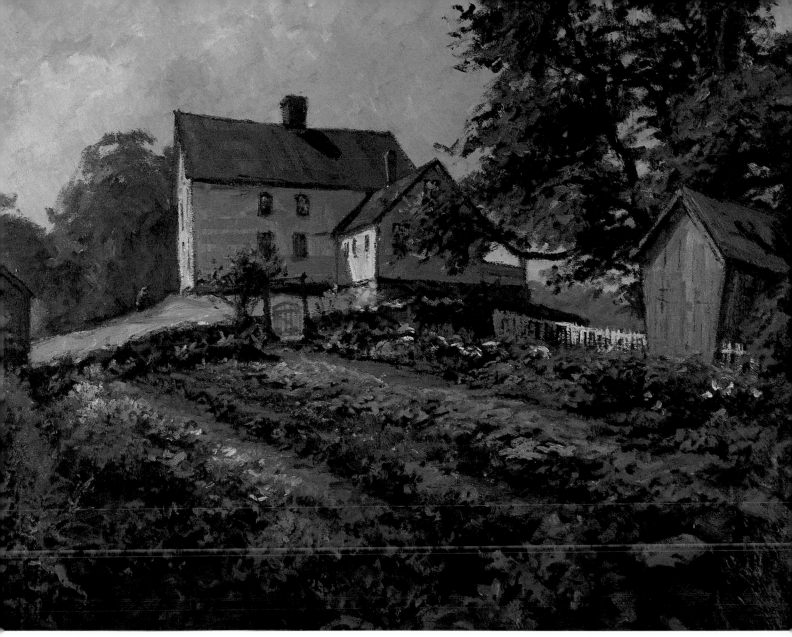

Marvin's Garden, 24" × 30"

SOLUTION

As I have stressed many times, you must be able to tell yourself exactly what the solution is to your problem *before* you ever start to paint. In this case, the story I was telling was about the farm and its garden, so I devoted less of the canvas to the sky. Also, I wanted a feeling of some clouds, but I kept their definition soft and unspecific. As for value, I wanted no lights on the clouds as light as on the house, or the light on the lawn, so the sky wouldn't attract competitive attention. All this I decided regardless of what sky was actually there. With the overall green of a summer painting, it is desirable to introduce a complementary *warm* color whenever possible, so I did this very subtly in the clouds.

Other decisions make this a better solution. By coming in closer to the subject, I was able to get into more interesting detail in each item as I painted it. I brought up the trees on the left side against the house, creating a greater feeling of light splashing on the old clapboards.

Notice the interesting color variations I introduced into the shadow side of the farmhouse, and that the value is darker but still luminous. The light playing on the lawn is now lighter than the shadow side of the building. Also notice that there is a greenish tinge on the shadow side, from the reflected light off the grass. I painted a little outhouse on the left so the viewer's eye would be held in the center of interest.

The stone wall in the foreground was handled very casually with lots of weeds and vines growing over it. I kept lights off of it so the viewer's attention would sweep across the garden up to the house.

With the composition cropped closer, the tree on the right guides the viewer's eye down to the center of interest, as does the directional thrust of the garden.

123

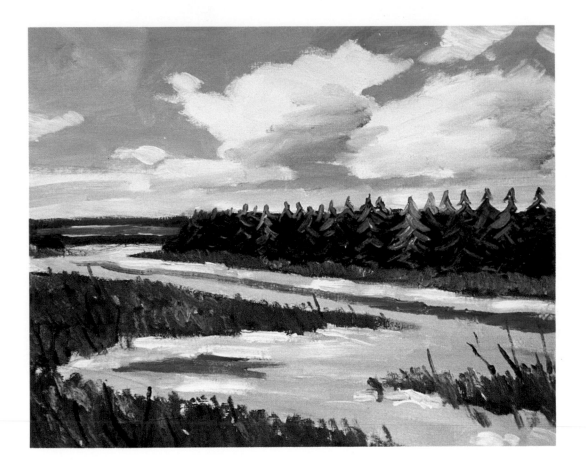

PROBLEM

This is a classic example of the student not deciding *what* he wanted to say before he started to paint. The canvas was divided in half, with equal space devoted to sky and landscape. Each section is clamoring for the attention of the viewer, and the eye jumps all over the composition.

The sky is designed in such a way—coupled with the diagonal thrust of the stream—that the eye of the viewer is likely to leave the center section without looking at the sky because there is nothing to block the exit on the left.

The weeds in the foreground are all painted a monotonous burnt sienna, and there are no variations in the pines across the stream. Faced with a mass like this, students tend to line them up like soldiers on parade. Also, because of a lack of observation, they tend to make the tops of the trees the way you find them drawn on cheap Christmas cards, with the branches at the top slanting

down. Actually, on fir trees the uppermost branches, being lighter in weight and shorter, point upward, as you see opposite.

Even in a forest dominated by evergreens, you find interesting variations of color and design from the bare branches of deciduous trees among them. Also see how interesting it becomes when you notice that not all the snow has been blown off or melted from the evergreen branches.

The open water in the ice-covered stream goes right up the center all the way, a very uninteresting design. Mistakes like this are made because students think they know the solution and don't go to nature and observe it. Believe me, there is nothing like seeing the real thing right in front of you.

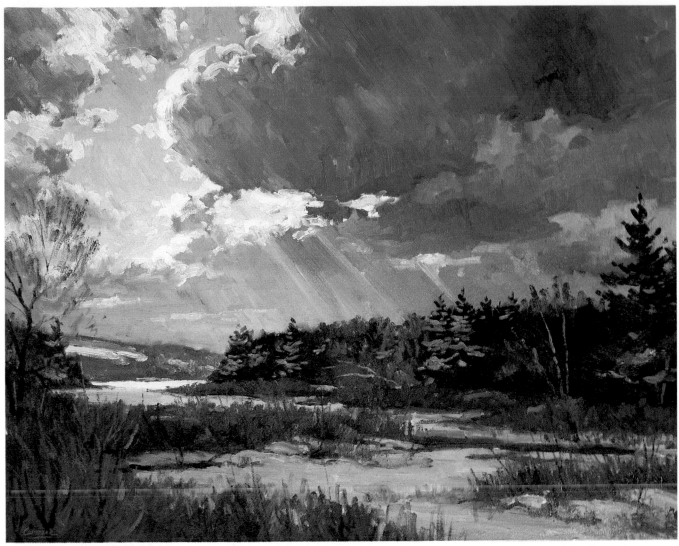

December Drama, 24" × 30"

SOLUTION

In this painting, I devoted two-thirds of the canvas to the sky. I threw the entire foreground and middle ground into a cloud shadow, thus eliminating any lights in these areas that would compete. I also introduced the tonal climax—lights adjacent to darks—right up in the sky, where I wanted the viewer's attention to go.

The main idea in painting clouds is to introduce as much color as you dare while staying within the limits of possibility for the time of day and weather conditions you're depicting. In general, though, I can safely say that most beginners are not daring enough. The large areas of gray are composed of the three primary colors. The idea is to realize the beautiful variations of colors possible, and not lose them by overmixing. In addition to the cloud forms, I've suggested rays coming from the sun in the upper left, outside the painting.

To paint skies successfully, you must make a study of them. Take your pastels or paints outdoors and make color sketches of the various cloud formations. In this way, you'll build an understanding of their shapes, colors and designs, so that you'll have knowledge to fall back on when you try to capture a fleeting effect like this.

There is so much waiting to be said with your paints, but it's so important to first learn your craft. No matter what stage of development you are in, you can always do it better. In fact, if it were not for the marvelous challenge that art provides, and the inner satisfaction when you meet that challenge and conquer it, I would not be writing this book.

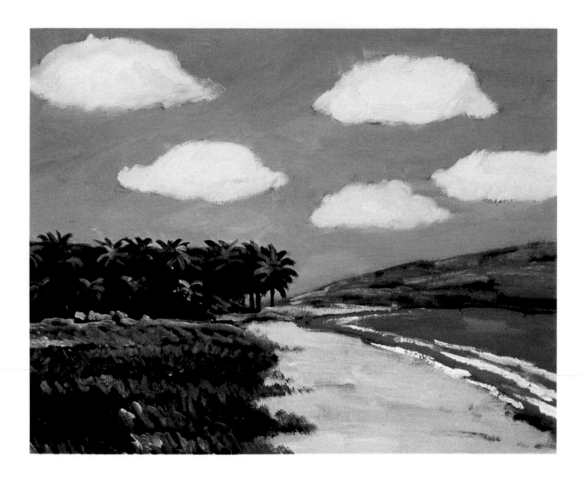

PROBLEM

A characteristic trait of unprofessional painting is a plain blue sky that hangs down behind the scene like a flat, blue curtain. When the novice has the courage to introduce clouds in his painting, they are usually symmetrical puff-balls of cotton, as we see here. In addition, the clouds are placed at too regular intervals in the sky area, and they do not exhibit the progression in size that would make them recede into the distance.

Let's go over the other definite wrongs in this problem painting. First, the composition is divided too equally between sky and land—one rivals the other for the viewer's attention. Then in the foreground, the beach is divided equally between sand and shrubbery, and the line of the water comes directly out of the lower right corner of the composition. The design of the palm trees shows little variety, and we zero in on the one directly in the center, with the branches shaped like big bananas.

No attempt was made to cast interesting lighting on the subject. The water is badly painted both in color and design.

This was one of the most delightful spots I found on a sailing vacation in the Virgin Islands. But no matter how lovely and fascinating the subject is, if it is not handled well, it can result in a rather sorry painting.

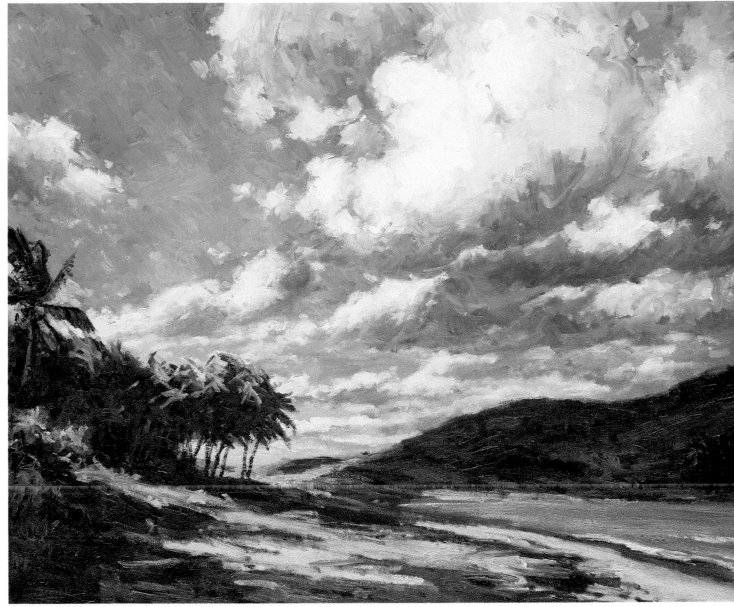

Peter Island, B.V.I., 24″ × 30″. Courtesy of Dr. and Mrs. Carl C. Conrad.

SOLUTION

The big decision in your painting should be: Are you saying "sky" or are you saying "landscape"? In most of the paintings in this book, I have stressed holding the sky down so that it complements, but does not upstage, the rest of the painting. When you decide to go all out and paint a sky, then subordinate the landscape. Here, most of the canvas is devoted to the sky; only about one-third is given to the land area. I have kept the viewer's attention primarily in the sky by throwing much of the land in shadow. Notice how part of the sky is open and cloudless, and part of it dense and cloudy. The sky is actually a great, big abstract design made up of clouds and blue sky. The clouds are larger and taller as they get nearer to the sun, and recede into the distance, one behind the other. Cumu-

lus clouds like these should not look like cotton puffballs. Instead, they should be flat-bottomed masses, with form and modeling and a definite shadow side. They should also be diversified in shape and design.

Clouds have a specific form and structure — you should make studies of various types. I have sat for hours making notes of their many moods and changes to build up a backlog of knowledge about them.

One of the main factors in outdoor painting is that conditions don't stand still for you. Dramatic effects, such as the one you see here, are painted primarily from memory and previous knowledge. The first prerequisite to making such a painting is to visualize the dramatic possibilities before you start.

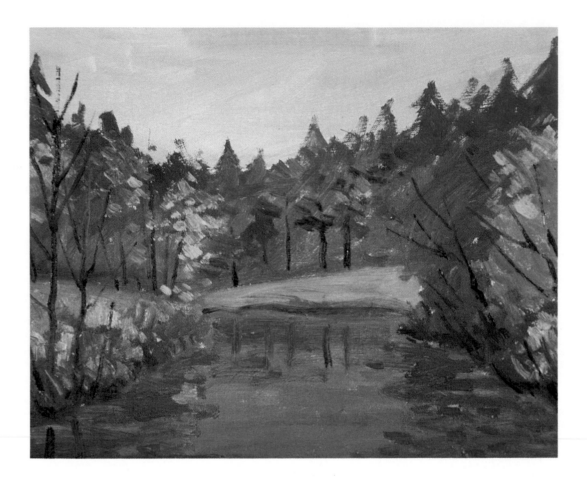

PROBLEM

I must remind you that before you start to paint you should say to yourself, "What am I trying to say, and how can I best say it?"

Here, the purpose of the painting is to display the spectacular colors that nature provides for us each autumn. Study these two examples, and see if you can analyze why this one fails in its rendition and the one opposite succeeds. When you can read a painting, you will be able to analyze your own work, tell yourself what to do, and know where you have made a mistake.

In the above painting, the importance of values was completely ignored. As in most students' work, there is not enough contrast between lights and darks. The sky is much too light, and it robs any effect of brilliance from the foliage. The rest of the values in the painting are all too similar.

The general composition is too symmetrical in both the design of the stream and the tree line against the sky.

The wonderful colors and patterns in a stream can seem overwhelming to beginners, and they usually end up with a half-hearted version, as I'm showing you here. Again I repeat, studio training can help you see and render beautiful colors, values and patterns. I can't emphasize this point enough to the landscape painter.

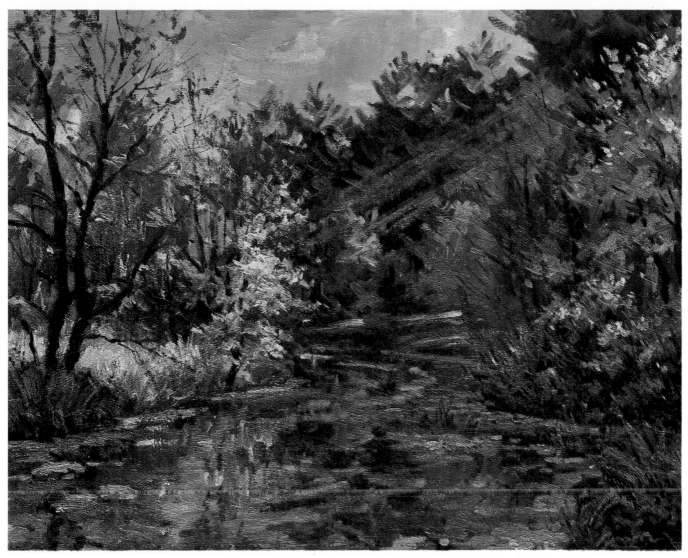

Spectacular September, 20" × 24"

SOLUTION

As a rule, skies are lighter than the objects that come up against them. But in this painting, I wanted to show the almost unbelievable brightness of color on the yellow tree as the sun splashed light on it and raised it to a brilliant crescendo. So, I had to find a way to paint the sky so it wouldn't compete with the bright foliage.

You can make any passage in a painting a little lighter or darker than it actually is—but you should have a *reason* for doing it. When you've made a color about as bright as you can and still want it to appear more so, you have to depend on what I call the *principle of relativity*, that is, contrasts, to do it. In other words, if you can't raise the bridge, you must lower the river. This is exactly what I did here. By making the blue of the sky darker than the highlights on the foliage on the yellow tree, I forced the tree to appear even brighter than it would otherwise. This

is a simple device, but if you know how and when to use it, it will be a valuable asset to your painting vocabulary. The fact that the deep, rich blue of the sky color was the complement of the tree color was also of great importance. The dark of the evergreens in the background also emphasizes the golden foliage in the center.

One of the critical tests of value judgement is to paint the shadow portion of autumn foliage luminous, yet still darker than where it is hit by sunlight, as in the trees on the right.

Study the colors in the weeds and pond lilies. The suggested wind ripples in the stream's current lead the viewer into the center of interest—the golden tree. The rays of sunlight coming from the upper right of the composition do the same thing.

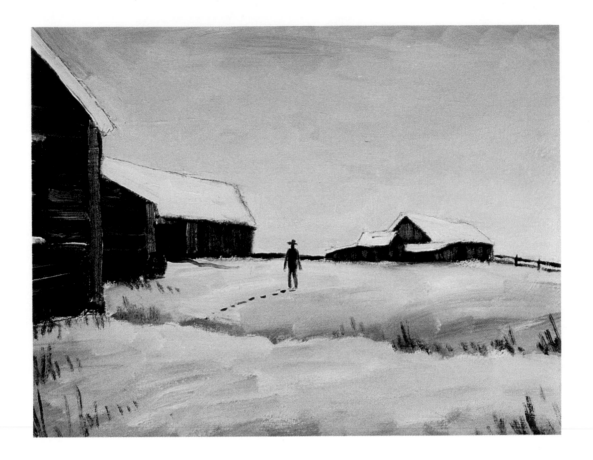

PROBLEM

Painting, to me, is a means of communicating. Once you decide *what* you're saying in the picture, you must get the viewer to look *where* you want him to, and hold down conflicting passages so they don't compete with the center of interest. In this painting, it's pretty obvious that the figure heading out to do the chores is the center of interest. Inasmuch as this activity is taking place in a scene rather limited in color—except for the sky, which is lightening with the early morning sun—this subject presents more problems than you might think at first.

The major problem in this sketch is that the morning sky is warm and that the snow is blue and white. Unfortunately, there's no relationship between the two, as there should be. (If the sky is warm, the snow would be warm,

and vice versa.) Also, with this much canvas devoted to the sky, there should be some pattern and design to it, without competing with the landscape. The values are off, too. There's no difference in value between the snow on the roofs and the sky behind them. The buildings in the distance are the same value and intensity as the one in the foreground, which means there's no aerial perspective—objects don't recede. Also, the grasses are handled in a clumsy, heavy-handed manner. All in all, this is a rather insensitive handling of a very charming subject.

A painting like this shows how much knowledge the artist has been able to accumulate and how much he can theorize, understand and paint from memory, without actually seeing the subject.

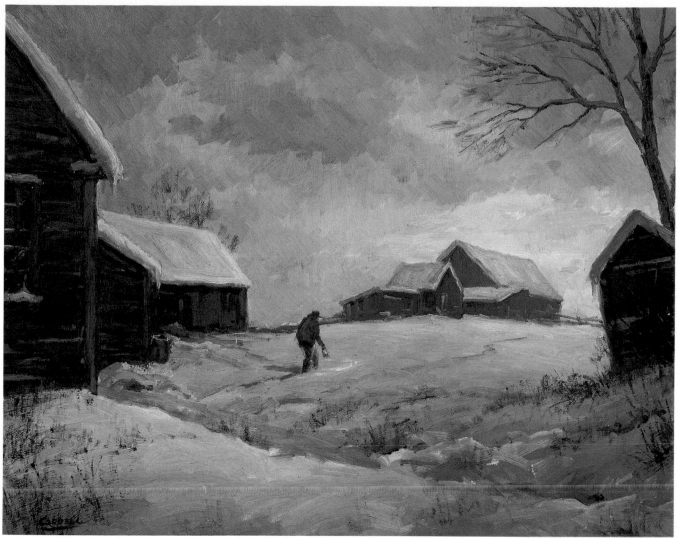

Morning Chores, 24" × 30"

SOLUTION

By now you're well aware of the importance I place on painting directly from nature — just about all my work is done on location. Occasionally, however, I enjoy a studio project such as the one you see here.

Although this was done in the studio, I spent much time studying morning skies. The sky had to have a delicate balance in design and value. I wanted color, too, but not so much that it rivaled the lantern. The sky needed some cloud formations, but could not become so busy and interesting that it would overshadow the center of interest. I could have handled all this very differently if I hadn't decided to make the figure the center of interest.

The general source of illumination is the glow in the morning sky. It reflects off the snow as it would off water. On the other hand, surfaces not facing the distant sky, such as the snow on the roof of the near building, become a darker gray, since they're illuminated from the sky

above. With enough studio still-life training, you can theorize these causes and effects because they're based on logic and physics.

The relationship between the sky and the snow color creates harmony. The colors of the sky, painted with a subtle combination of Naples yellow and alizarin crimson, and grayed with cerulean blue, are reflecting on the snow in the barnyard just as they would on a body of water. The color and values of the snow on the roofs of the barns are painted darker than the sky so that there's a value differentiation between them. The warmer sky colors were introduced into them while the paint was still wet. I drybrushed the grass and weeds over the snow when it was dry for a light, feathery effect.

I feel that a studio painting like this can be done successfully only if you spend enough time painting directly from nature.

CONCLUSION

While working on this book, I gave a great deal of thought to just what to say to you in the conclusion. If I knew each one of you personally, as I do my own students, my suggestions could be more personal, based on my observations of your work. In this instance, I can only make some general observations and trust that you'll interpret them in the light of your own ability and degree of experience.

I don't go to exhibitions very often, but when I do, I'm struck by the mediocrity of much of the work. I'm not talking about the big national shows, but those on the state and local level. To me, this means that too many painters are settling for a level that could be much higher. As I've said before, when you hang up a painting for all to see, you're telling the whole world how much you know and also how much you *don't* know. The only salvation is that most people viewing the work can't read what you're saying. To many lay people, an oil painting "done by hand" is practically an act of God.

Now, don't feel that I'm critical of all amateur work. None of us were born geniuses. All of us had to work our way up the ladder. The ones I feel sorry for are those who *think* they've arrived and are settling for making paintings to sell rather than growing, learning and working desperately to become better artists. My attitude and advice is nothing that I don't follow myself.

My reason for teaching and for writing this book is to share my knowledge with you, just as others have helped me. The letters I've received from remote places all over the world have made me realize how many people are struggling to paint and need help. Books and magazines are the only way some of them can study. Thus, *The Artist's Magazine* and North Light Books deserve a great deal of credit for bringing information to people in these remote areas.

The hardest student to help is the one who thinks he's arrived. It's hard to admit to yourself that you're not quite as good as you and your relatives think you are, for this would mean lots of hard work to do something about it.

So often students are overly concerned with having their style affected by studying with a teacher. But, with this attitude, they limit their advancement and close their mind to all new ideas. A classroom is not the place to preserve your individuality. Rather it's a place to get all the training possible to enable yourself to advance to the level where you can speak for yourself, in your own style, *after* you've left the classroom.

Throughout this book, I've encouraged you, as a serious painter, to get some good instruction in studio work. But *don't* go to a class that copies prints or photos. Some classes do this, but to me, it's chewing gum for the mind, and I'd give up teaching before I'd conduct classes in such a manner. If you, as a student, are doing this, I'd like to give you some second thoughts on this matter. To me, copying has only one good reason to exist—and that is the way it was done years ago in museums by struggling students who were trying to pick the brains of the long-dead Masters. In trying to re-create a Velazquez or Rubens, you had to try to imagine the way the Master thought and the reasoning behind his work. It may be easier for the teacher to use photos or pictures, and it is certainly easier for students to copy, but many are making "pictures" and exhibiting and selling them before they really know how to paint. You can see this type of work in many local exhibitions, and by the trained eye, they can be spotted in a minute.

Another type of class that pleases some students but hinders their ultimate advancement is that in which the teacher sketches out practically the entire picture and the student helps "finish it up." You're sure to go home with a painting far better than you're capable of, but this, of course, is not learning.

Let me share some other thoughts with you. One of the biggest problems in teaching is that students expect to make good paintings before they've studied and trained enough. This isn't possible in any other profession, so why should it be in painting? Believe me, the higher you wish to climb the ladder to professionalism, the harder it gets. When students are disappointed that they're not doing better, I remind them that their advancement will be in direct proportion to the time they devote to painting.

Many painters want to study portraiture long before

they're ready for it. Doctors who have been painting students remark that a portrait is as difficult as a major operation. Many students want to reach the top without the hard work that is necessary, but there's no easy way. What I'm really trying to instill in you is a great desire to paint better and a willingness to work hard at developing your skill. The fact that most of your viewing audience can't determine whether you paint well or not is no reason to fool yourself. When a singer comes out onstage, most people only relate to the songs he sings. Only a small percentage of people are judging how well he's doing and how he compares to other great singers, or even to himself ten years ago. But those are the people that the singer should be thinking about—and that's the kind of person that exhibitors should think about, too.

Sooner or later, you must make up your own mind as to what you think is great art, and have the courage of your own convictions to stick to it. So many artists are overly concerned with what type of painting is "in." The paint isn't a certain style or manner to get accepted in certain exhibitions or to catch the attention of an art critic. Another old saying, although facetious, has a great deal of honest logic: "No one ever built a monument of a critic." I long ago decided on the path I thought was right for me, and I stuck to it, regardless of whether it was "in" or "out."

To me, art should be the searching for beauty and truth. I strive for classical timelessness that will, I trust, stand long after trends and vogues will have passed into history, and future generations will wonder how they could ever have existed at all. I seek beauty in a time when many are afraid to admit it, fearing they would be termed square and out of step with their time.

I place great importance on the craft of painting, for without it, I could not fully convey my emotional reaction to visual stimuli. I try to take the ordinary in life and make it extraordinary by the way I portray it. I seek to capture a mood, either in a landscape or a figure study, and transmit this feeling. To me, art is first and foremost a means of communication between the artist and the viewer.

I am fortunate in getting great pleasure from painting a wide range of subject matter. I can get as enthused about a formal portrait commission as I can about a landscape. Every time I make a painting, it is a great experience, and even though I am a teacher, I learn something new each time I pick up a brush.

I am currently conducting workshops around the country, and I hope many of you will be able to attend them. It gives me the opportunity to make comments specific to the individual's work, and for them to be able to ask questions.

I sincerely hope that I've spurred on your desire to become a better painter, as well as your willingness to put in the necessary work and study to accomplish it. I trust that the problems and mistakes I've seen in my own students' work and presented to you here will make you more aware of your own shortcomings and help you overcome them. If this is true, then this book has served my intended purpose for both of us.

Index

Improve your skills, learn a new technique, with these additional books from North Light

Business of Art

Artist's Market: Where & How to Sell Your Art (Annual Directory) $22.95

Artist's Friendly Legal Guide, by Floyd Conner, Peter Karlan, Jean Perwin & David M. Spatt $18.95 (paper)

Fine Artist's Guide to Showing & Selling Your Work, by Sally Prince Davis $17.95 (paper)

Handbook of Pricing & Ethical Guidelines, 7th edition, by The Graphic Artist's Guild $22.95 (paper)

How to Draw & Sell Cartoons, by Ross Thomson & Bill Hewison $19.95

How to Draw & Sell Comic Strips, by Alan McKenzie $19.95

How to Succeed As An Artist In Your Hometown, by Stewart P. Biehl $24.95 (paper)

How to Write and Illustrate Children's Books, edited by Treld Pelkey Bicknell and Felicity Trotman, $22.50

Watercolor

Basic Watercolor Techniques, edited by Greg Albert & Rachel Wolf $16.95 (paper)

Buildings in Watercolor, by Richard S. Taylor $24.95 (paper)

The Complete Watercolor Book, by Wendon Blake $29.95

Fill Your Watercolors with Light and Color, by Roland Roycraft $28.95

How to Make Watercolor Work for You, by Frank Nofer $27.95

The New Spirit of Watercolor, by Mike Ward $21.95 (paper)

Painting Nature's Details in Watercolor, by Cathy Johnson $22.95 (paper)

Painting Outdoor Scenes in Watercolor, by Richard K. Kaiser $27.95

Painting Watercolor Portraits That Glow, by Jan Kunz $27.95

Painting Your Vision in Watercolor, by Robert A. Wade $27.95

Splash 2: Watercolor Breakthroughs, edited by Greg Albert & Rachel Wolf $29.95

Tony Couch Watercolor Techniques, by Tony Couch $14.95 (paper)

The Watercolor Fix-It Book, by Tony van Hasselt and Judi Wagner $27.95

The Watercolorist's Complete Guide to Color, by Tom Hill $27.95

Watercolor Painter's Solution Book, by Angela Gair $19.95 (paper)

Watercolor Painter's Pocket Palette, edited by Moira Clinch $15.95

Watercolor Tricks & Techniques, by Cathy Johnson $21.95 (paper)

Watercolor Workbook, by Bud Biggs & Lois Marshall $22.95 (paper)

Watercolor: You Can Do It!, by Tony Couch $29.95

Webb on Watercolor, by Frank Webb $29.95

The Wilcox Guide to the Best Watercolor Paints, by Michael Wilcox $24.95 (paper)

Mixed Media

The Artist's Complete Health & Safety Guide, by Monona Rossol $16.95 (paper)

The Artist's Guide to Using Color, by Wendon Blake $27.95

Basic Drawing Techniques, edited by Greg Albert & Rachel Wolf $16.95 (paper)

Basic Landscape Techniques, edited by Greg Albert & Rachel Wolf $16.95

Basic Oil Painting Techniques, edited by Greg Albert & Rachel Wolf $16.95 (paper)

Being an Artist, by Lew Lehrman $29.95

Blue and Yellow Don't Make Green, by Michael Wilcox $24.95

Bringing Textures to Life, by Joseph Sheppard $19.95 (paper)

Capturing Light & Color with Pastel, by Doug Dawson $27.95

Colored Pencil Drawing Techniques, by Iain Hutton-Jamieson $24.95

The Complete Acrylic Painting Book, by Wendon Blake $29.95

The Complete Book of Silk Painting, by Diane Tuckman & Jan Janas $24.95

The Complete Colored Pencil Book, by Bernard Poulin $27.95

The Complete Guide to Screenprinting, by Brad Faine $24.95

Tony Couch's Keys to Successful Painting, by Tony Couch $27.95

Complete Guide to Fashion Illustration, by Colin Barnes $11.95

The Creative Artist, by Nita Leland $21.95 (paper)

Creative Painting with Pastel, by Carole Katchen $27.95

Drawing & Painting Animals, by Cecile Curtis $26.95

Drawing For Pleasure, edited by Peter D. Johnson $16.95 (paper)

Drawing: You Can Do It, by Greg Albert $24.95

Exploring Color, by Nita Leland $24.95 (paper)

The Figure, edited by Walt Reed $16.95 (paper)

Getting Started in Drawing, by Wendon Blake $24.95

Getting Started Drawing & Selling Cartoons, by Randy Glasenbergen $19.95

Handtinting Photographs, by Martin and Colbeck $29.95

How to Paint Living Portraits, by Roberta Carter Clark $28.95

Keys to Drawing, by Bert Dodson $21.95 (paper)

Light: How to See It, How to Paint It, by Lucy Willis $19.95 (paper)

The North Light Illustrated Book of Painting Techniques, by Elizabeth Tate $29.95

Oil Painting: Develop Your Natural Ability, by Charles Sovek $29.95

Oil Painting: A Direct Approach, by Joyce Pike $22.95 (paper)

Oil Painting Step by Step, by Ted Smuskiewicz $29.95

Painting Animals Step by Step by Barbara Luebke-Hill $27.95

Painting Flowers with Joyce Pike, by Joyce Pike $27.95

Painting Landscapes in Oils, by Mary Anna Goetz $27.95

Painting More Than the Eye Can See, by Robert Wade $29.95

Painting the Beauty of Flowers with Oils, by Pat Moran $27.95

Painting the Effects of Weather, by Patricia Seligman $27.95

Painting Towns & Cities, by Michael B. Edwards $24.95

Painting with Acrylics, by Jenny Rodwell $19.95 (paper)

Pastel Painter's Pocket Palette, by Rosalind Cuthbert $16.95

Pastel Painting Techniques, by Guy Roddon $19.95 (paper)

The Pencil, by Paul Calle $19.95 (paper)

Perspective Without Pain, by Phil Metzger $19.95

Photographing Your Artwork, by Russell Hart $18.95 (paper)

Putting People in Your Paintings, by J. Everett Draper $19.95 (paper)

Realistic Figure Drawing, by Joseph Sheppard $19.95 (paper)

Sketching Your Favorite Subjects in Pen and Ink, by Claudia Nice $22.95

Tonal Values: How to See Them, How to Paint Them, by Angela Gair $19.95 (paper)

Art & Activity Books For Kids

Draw!, by Kim Solga $11.95

Paint!, by Kim Solga $11.95

Make Cards!, by Kim Solga $11.95

Make Clothes Fun!, by Kim Solga $11.95

Make Costumes!, by Priscilla Hershberger $11.95

Make Prints!, by Kim Solga $11.95

Make Gifts!, by Kim Solga $11.95

Make Sculptures!, by Kim Solga $11.95